# DRAWING FOR SCIENCE, INVENTION & DISCOVERY

## Even if you can't draw

thanks so much for the support

**Paul Carney**

PAUL

Thanks so much for the support :)

Paul

# DRAWING FOR SCIENCE, INVENTION & DISCOVERY

## Even if you can't draw

**Paul Carney**

First published in 2018 by: Loughborough Design Press Ltd, 6 Mulberry Way, Rothley, Leicestershire, LE7 7TX

For information on all Loughborough Design Press publications, please visit our website: www.ldpress.co.uk

Printed by Printondemand-worldwide.com, UK

The product is FSC and PEFC certified.

**PEFC Certified**

This product is
from sustainably
managed forests
and controlled
sources

www.pefc.org

**PEFC**™

PEFC/16-33-415

**Mixed Sources**

Product group from well-managed
forests, and other controlled sources
www.fsc.org  Cert no. TT-COC-002641
© 1996 Forest Stewardship Council

**FSC**

ISBN: [paperback] 978-1-909671-19-5

eISBN: [mobi] 978-1-909671-20-1

Book design: Eddie Norman

Cover design: Paul Carney, featuring his drawing made whilst doing the visualisation exercise (see page 75, Visualising Information). Paul has used visualisation skills to try to represent the movement of people entering a room. He has not tried to represent the form of the people, merely their motion.

## ACKNOWLEDGMENTS

I'd very much like to thank Eddie and the team at Loughborough Design Press for having faith in this project. I'd also like to thank Susan Coles and the NEATEN (North East Art Teacher Educator Network) team for their continued inspiration, love and support and my wife Angie, despite her (perceived) lack of drawing ability, for being my Guinea Pig for most of the drawing exercises.

But I'd really like to thank Alice Roberts for responding so kindly to my work and making me believe that it was relevant.

Paul Carney

*www.paulcarneyarts.com*

August 2018

## ILLUSTRATIONS

Fig 0 Anatomy drawing by kind permission of Alice Roberts

Fig 1 Photo 51, Rosalind Franklin and Raymond Gosling 1952, by kind permission of King's College London

Fig 8 *From Life*, Borland Christine 1994. Photo by kind permission of Christine Borland

Fig 12 Hubble Space Telescope's images of Pluto, courtesy of NASA

Fig 13 Pluto as recorded by NASA's New Horizons spacecraft on July 13, 2015, courtesy of NASA

Fig 17 Notebook page, copyright John Sulston, with kind permission of the Wellcome Collection

All other drawings and photographs are by Paul Carney who holds their copyright and has given permission for their use.

# CONTENTS

## FOREWORD
### *Professor Alice Roberts, University of Birmingham*

"Drawing," writes Paul Carney, "is much more than a vague, abstract notion; it is deeply rooted in what it means to create rational thought."

I remember the dismay I felt when, at the age of sixteen, it seemed that I would have to give up doing art at school in order to fit in physics. I loved them both. I needed physics A level in order to apply to medical school. And while the university admissions teams might not have cared a jot whether or not I'd continued art to A level, I needed to.

Even back then, I found the hard lines drawn, the barriers erected, between different subjects, quite intrusive and even arbitrary. I knew how much drawing had helped me with the sciences - from sketching out quite abstract ideas in physics to painstakingly outlining the reproductive organs of a flower in biology classes, or drawing the macabre still-death of a freshly dissected rat, its organs laid bare for me to sketch and comprehend. The process of drawing itself helped me to understand - I had to look carefully, pick out salient features, and make a record that I knew would stick in my memory so much more easily than a list of words. But art wasn't just a way of helping with the sciences, a handmaiden to the subjects now obscurely and pompously referred to as STEM (as though they are so important you should immediately know what this acronym means; as though they're so important that they are central and trunk-like, while the arts and humanities are confined to the periphery: pretty, ornamental leaves; nothing more). Art helped me see and approach the world in a different way, and I knew that I would be impoverished without it.

And so I did both physics and art A level. Though physics was, of course, the subject that demanded its true place in the curriculum, while art was relegated to the interstices - I fitted it in around the rest: in my lunchtimes, my study periods, my evenings. I may have been estranged from the A level art class, but my wonderful teacher, Mrs Sutherland, made me feel secure in my exile.

Once at medical school, drawing became my primary tool for learning my favourite subject of all, anatomy. I would draw and draw and draw the structures of the human body - copying out diagrams and pictures from my old edition of Gray's Anatomy, and from my gorgeous two-volume Sobotta (which I had quickly realised was the epitome of anatomical atlases, being both stunningly beautiful and unerringly accurate; my grandparents had bestowed it on me as a christmas present, shelling out what they must have felt was far too much for a book, even two books). And I took my sketchbook into the dissection room and drew the body I was dissecting with my student friends: six of us around a body, battling with layers of thick, greasy, yellow fat and the dissembling fascia in order to reveal the intricacies of organs, nerves, vessels, muscles and tendons. Like everything that went into the dissection room and came out, the sketchbook gathered its own, not-so-subtle, aroma of sweet formalin - a scent familiar to any medical student in the 1990s, or indeed, to any other student who happened to live in close quarters with one of us. But as surely as the smell of the fixatives seeped into the pages of my sketchbook, the drawings of human anatomy seeped into my brain, colonising my synapses with a mental map of the landscape of the body.

As a doctor, I used drawings to explain surgery to my patients. Then I took a side-step into academia, and drawing became my ally as I taught medical students, dental students and vet students anatomy - sketching structures on the blackboard (and latterly, the vastly inferior whiteboard) as I lectured, preparing handouts with more pictures than text. The students loved them. And they responded with their own drawings, in answer to my exam questions and in their projects. And recently, when I sat down to try to probe into the mechanics of joints with my PhD student, we sketched out ideas together, working out hypotheses in pictures before we articulated them in words. We weren't just drawing to remember; we were drawing to understand.

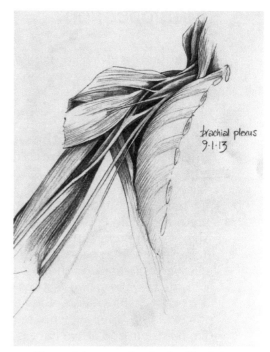

**Figure 0** Anatomy drawing by Alice Roberts

(By kind permission of Alice Roberts)

Drawing has had a bit of a renaissance recently: a plethora of books and apps have appeared, promoting drawing for mindfulness. And this time I think it's more than just a bit of quackery and faddishness; for me at least, drawing directs attention in a way that seems to creates focus and a feeling of deep serenity at the same time. But the process of drawing does more than unlocking this state of mind; it can inspire creativity. It complements rational investigation. It helps us create and remember and build on our mental models of the world around and within us.

In this book, Paul Carney considers the differences and similarities between the processes of science and art, and writes about how observation, adaptation, collaboration, knowledge and serendipity play roles in the pursuit of both. These comparisons then lead into practical exercises. No matter where you're starting from - whether you've always loved drawing, or you're just trying it out; or whether you think of yourself as an 'artist' or a 'scientist' - I think the exercises in this book could help to make you a better draughts-person and encourage you to realise your own creative potential.

This is also a book about iconoclasm. The icons to be smashed are not the subjects of our education themselves, carefully divided and corralled, but the walls between them. Those walls only really exist in our minds. So: free your brain ; unlock your creativity - start drawing!

*Alice Roberts*
*Author; anatomist; broadcaster; drawer of things*

# 1. INTRODUCTION

'The process of drawing is before all else the process of putting the visual intelligence into action, the very mechanics of taking visual thought.'

(Ayrton, 1957: 64)

## What are the traits of the world's greatest innovations and discoveries and can they be learned through drawing?

Scientists call it curiosity. Artists call it motivation or a muse, but they're two sides of the same coin. Curiosity and motivation have taken us to the top of mountains, to the north and south Poles, to the depths of the oceans and to the surface of the moon. They've sent probes into outer space, space ships to Mars and even seen beyond our Solar system. They've helped us solve our worst humanitarian crises, cured some of our worst diseases, given most of us more comfortable, healthier lives and helped construct awe inspiring feats of engineering. Curiosity and motivation defines us as a species and have contributed to the greatest discoveries, innovations and creations the world has ever known. Creativity is fuel for the fire of curiosity. Without it, the fire burns out and all we have is what we know. But keep it burning and anything is possible, at any age, in any location.

The objectives of this book are to identify the mechanisms from which the world's greatest inventions and discoveries come about and to demonstrate that these can be illustrated, explained and taught through drawing. Whether you can draw or not is irrelevant, because the quality of outcome or end product is not what we are seeking. What is crucial is the cognitive process you'll go through.

So why drawing? Drawing is a profoundly important tool in the development of human consciousness. It originated long before we developed writing and in fact, as babies we still draw before we can read or write. Even writing itself is simply a form of drawn symbolism. Drawing helps us visualise our thoughts and ideas, it helps us describe things and provides information and instruction with vivid clarity. Most man-made things began life as a drawing.

In *Sketches of Thought* Vinod Goel (1995) argues that a cognitive, computational conception of the theory of mind requires our thought processes to be precise, rigid, discrete, and unambiguous. Yet this computational model does not account for ambiguous, and amorphous symbol systems, like sketching, painting, and poetry, found in the arts. So any complete cognitive model needs to account for these internal symbolic systems. This implies that drawing is much more than a vague, abstract notion; it is deeply rooted in what it means to create rational thought. In addition, in *Thinking with Sketches* Tversky & Suwa (2005) argue that sketches serve to externalise ideas and turn internal thoughts and concepts public. Using sketches in this way, as a form of schematic vocabulary, requires constructive perception, a combination of a perceptual skill of reconfiguring and a cognitive skill of finding remote associations. So drawing is an important mechanism in our capacity to think, imagine and realise our cognitive intentions.

Drawing aids the learning process too. In two studies at the University of Massachusetts and Stanford University, Eliza Bobex and Barbara Taversky (2009) found that students who had created visual explanations of Science, Technology, Engineering and Maths (STEM) phenomena performed better in a post-test than those who had created verbal explanations. To that end, drawing is a cognitive tool, a means of visualising and rationalising our thinking and if it can do that, then it is logical that we should enhance and develop that skill.

This book is aimed at anyone interested in how we innovate, but especially scientists, inventors and problem solvers, as well as teachers and educators of STEAM subjects; Science, Technology, Engineering, Art and Mathematics, to help them develop more creative, critically aware students. STEM teachers may find these exercises useful to visit with their students on a regular basis, both to illustrate aspects of real practice and to broaden the capacity for creative thinking. I must stress that you don't need to be able to draw realistically to learn from the drawing process. There are a myriad of different ways to draw and few of them are about accurate representation. Besides, if you can write your name you can draw anything. Art teachers should find these exercises useful to develop the range of skills they and their students possess and also how art links to the wider world, because above all art is about thinking and this is never done in isolation. It's pointless doing the same tired drawing exercises again and again, we have to find fresh, innovative approaches to how we see and interpret the world, because the world is constantly changing.

My exercises attempt to demonstrate simple, practical techniques that can improve understanding of how innovation occurs and improve the ability to discover, invent and create. They should help scientists and engineers to become more cognitively flexible practitioners and help artists to think more laterally and diversify their process. I have developed many of these exercises specifically for this book and employed some familiar drawing exercises from the world of art education. Hopefully these will be cast in a new light and so gain a different meaning as a result. I've also adapted some exercises used by practicing artists that I thought were especially useful, though again, I've tried to put my own twist on them and make them more relevant.

My profession is that of an educator in art and design, but I am also passionate about science and all things technological. What I try to see when I study these disciplines as an amateur is not only the incredible achievement, but also the thinking processes that led to these great innovations. Just as I am always fascinated by the root motivation behind an artist's thinking and methodology, so I want to understand the where, when and why of invention, discovery and innovation. What I'm trying to do here in effect is to dig down in the dirt and pull up the roots of how things happened. What I find so intriguing is that the root causes of human achievement have such overlap with the driving forces of the greatest artistic expression. This book tries to encapsulate these cognitive processes and attempts to teach them in a formalised way. After all, you can't create anything unless you know the mechanisms of creation.

In the course of my research I've identified many traits behind the world's greatest innovations and often there are several wrapped up in the same breakthrough. But I've focused on nine traits here; observation, collaboration, knowledge, serendipity, methodical, alternative viewpoints, trial and error, and visualising. The ones I've chosen are ones I see time and time again across most fields of discovery and innovation.

In attempting to explain how these fields lead to innovation and how they might be taught through drawing, I have been conscious of striking a balance between evidence and practice. To that end I have structured the book into chapters where the proposing argument is supported with evidence from the scientific and mathematical world and the artists. I have also applied my own opinion as to how these fields relate, then provided you with the all-important means to promote these qualities in your students using art exercises. I hope this book will be of benefit to both art students and STEM students at all educational phases because, not only do I believe they are relevant, but I also believe they will benefit them. I have a secret wish that some practicing scientists might pick up the book and be inspired.

I believe that if we want our young people to become better innovators and solve some of humanities' problems, we need to teach them how to draw. Not only traditional, observational drawing, but new, cognitive drawing techniques that visualise and expand our thinking strategies. This is not a 'how to draw' book though, nor will it lead to pretty pictures that you can show your friends. It attempts to show you how drawing can manifest cognitive processes into visual forms. I hope, after reading this book that you develop your drawing skills and in the process discover something new.

'Our first endeavors are purely instinctive, promptings of an imagination vivid and undisciplined. As we grow older reason asserts itself and we become more and more systematic and designing. But those early impulses, tho not immediately productive, are of the greatest moment and may shape our very destinies.'

(Tesla, 1919: 18)

## 2. OBSERVATION

1. The act or instance of noticing or perceiving, regarding attentively or watching.
2. An act of viewing or noting a fact or occurrence for a purpose.
3. Something that is learned in the course of observing things.

(Wiktionary, 2018)

### How has observation led to innovation and discovery?

**Gravitational Waves**

Where artists use their eyes and hands to record their observations, scientists use these and many other devices to yield the data they are seeking. Human senses such as eyesight, hearing, smelling and touching are good up to a point, but for intricate observation that is outside human perception, more accurate equipment is needed: thermometers, microscopes, telescopes, radar, radiation sensors, X-ray crystallography, mass spectroscopy, etc.

Gravitational waves are ripples in space-time created by huge cosmic interactions. Think of the ripples in the surface of a calm pond that are created when a pebble is thrown into it. A similar thing happens in space when massive objects such as black holes collide. Gravitational waves were first theorised in 1893 by the remarkable self-taught electrician, mathematician and physicist Oliver Heaviside and later expanded upon by Henri Poincaré in 1905, but they had never been detected.

The LIGO (Laser Interferometer Gravitational-Wave Observatory) detectors in the US are two of the most sensitive instruments ever built. Situated at Hanford Observatory Washington and Livingston Observatory Louisiana, each LIGO detector has L-shaped antennae with arms almost four kilometres long. Inside the ends of each arm, mirrors of ultra-pure glass are isolated from any outside interference. A single beam of laser light is split and fired toward these mirrors whereupon it is bounced back to the detector. If the two returning laser light signals are the same length then they cancel each other

out and LIGO's detector sees nothing. But passing gravitational waves will stretch one arm and squeeze the other causing a discrepancy so tiny it is 1/10,000th of the width of a proton of light. This discrepancy is turned into a sound wave; a chirp, rather like the sound of a bubble bursting.

The purpose of this experiment is to find out more about gravitational waves, test the theories of relativity and gravity, and find out more about black holes, matter and stars. Since its commencement in 2014, LIGO has found numerous gravitational waves and advanced our understanding of how the universe works (LIGO, 2017).

**Observing the structure of DNA**
In the 1950s there was much rivalry between the scientific communities in Cambridge and London to identify the structure of DNA. Maurice Wilkins and Rosalind Franklin, partners at King's College London, did not see eye to eye which gave their rivals Francis Crick and James Watson at Cambridge an advantage. Wilkins had dismissed the pair as being like butterflies, flitting around but not doing anything (Wilkins, 2005). But while he and Franklin were struggling to get along, what Crick and Watson were in fact doing was building three-dimensional visual models, experimenting with structural patterns and seeing which shapes worked together and which didn't.

Crick and Watson were solving the problem by manifesting their mental calculations through physical, tangible means; modifying and altering their proposed structures by realising their ideas in three-dimensional forms, then deconstructing them through evaluation and counter-argument (in much the same way as a sculptor does). These often fractious debates helped them realise how different molecules fitted together. Key to their breakthrough was a chance glimpse of an x-ray crystallograph pattern of DNA produced by Rosalind Franklin and Raymond Gosling in 1952 known as photo 51. As soon as Crick saw the x-shaped image lying on Wilkins's desk it provided him with the vital insight he needed to solve the structure of DNA. They went on to win the Nobel Prize in 1962 for correctly identifying that the structure of DNA was a double helix, though Franklin went unrecognized by the prize committee.

**Figure 1** Photo 51, by Franklin and Gosling 1952, showing x-ray diffraction pattern of DNA.

(By kind permission of King's College London)

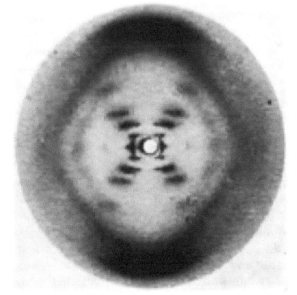

## Santiago Ramón y Cajal

**Weblink 1** More information about the life and work of Santiago Ramon y Caval can be found here: https://www.ncbi.nlm. nih.gov/pmc/articles/ PMC2845060/

Spanish scientist and Nobel Prize winner Santiago Ramón y Cajal, born in 1852, was a rebellious child who was imprisoned at the age of eleven for destroying his neighbour's fence with a homemade cannon. A gifted artist, he had an argumentative attitude. At the age of sixteen his father (an anatomy teacher) would take him to graveyards for the anatomical study of human remains. After his studies in 1887 Santiago became a professor in Barcelona, where he learned about Golgi's method of cell staining that allowed scientists to study neurons in the central nervous system. Since there was no formalised way of photographing such microscopic images he set about drawing what he saw in meticulous detail. He went on to make extensive drawings of neural pathways, covering several species and most regions of the brain, discovering the axonal growth cone and demonstrating the contiguous relationship between nerve cells. He also provided evidence for neuron theory; that the nervous system is made up of discrete individual cells and discovered a new type of cell, eponymously named the interstitial cell of Cajal (ICC).

Cajal's painstaking techniques have of course been replaced by the electron microscope, recording detail on scales that he could only dream of, but the implication of his 'old-fashioned' method is that drawing can bring greater clarity of understanding because ultimately drawing is a human tool that aids cognition. Furthermore, what to Cajal were precise observations appear to artists as beautifully rendered abstract compositions easily as engaging as a Gerhard Richter drawing or Mohammad Ali Talpur study.

## Artists who utilise intense observation in their work

Painting reality was the day-to-day staple of the Old Masters, from the great Italian Renaissance painters such as Leonardo da Vinci, Michelangelo, Raphael and Titian to the Dutch and Baroque artists such as Vermeer, Caravaggio and Rembrandt. The primary goal was to capture the essence of reality on the canvas. However, this was a carefully composed 'reality', arranged and positioned so as to convey allegories, metaphors and symbols to their pre-photographic audience. The artists couldn't make their subjects move as we can today in film, so they constructed narratives using the formal elements, body language, expression and posture, props and costume and the dynamic between object and space, colour, light and form.

## Albrecht Dürer

**Weblink 2** Albrecht Dürer's *Head of an Old Man* (1521) can be seen here: https://artsandculture. google.com/asset/ gEGacc7FCh0Ig

German artist Albrecht Dürer (1471-1528) was one of the leading artists of the Northern Renaissance. He established his reputation whilst still in his twenties for his exquisite woodcuts and was in contact with Italian masters such as Leonardo da Vinci and Raphael. He produced an enormous body of work including engravings, portraits, altarpieces and watercolours and he gained the patronage of Emperor Maximillian 1. He produced theoretical books on geometry called the Four Books on Measurement, where he drew on many leading sources to construct theories on drawing for architecture, engineering and typography. He also produced Four Books on Human Proportion basing his work on the empirical study of two to three hundred living persons.

He wrote about aesthetics at length. His wish was to be able to define beauty in artistic, scientific and mathematical terms so that others could replicate it. But he was not oblivious to the complexity of creating specific criteria for the rules of defining such beauty. He wrestled with this problem for much of his later life, developing the belief that an artist accumulates visual experiences from which they imagine beautiful things, rather than from spontaneous inspiration. For him, the artist's skill, accumulated over time, combined with the process of constant observation to build greater understanding were the criteria of making 'beautiful' art. For Durer therefore, developing the artist's eye, building visual knowledge over time and how to interpret it were as important as the mastery of technique. He was never able to precisely define the criteria for beauty for which he strove, but he did (along with many others in the Renaissance) lay the foundations of art as both a science and a mathematical expression of form.

### George Shaw

**Weblink 3**
More information about George Shaw and an example of his work can be found here:
https://www.tate.org.uk/art/artists/george-shaw-5253

Coventry artist George Shaw paints realistic urban landscapes of the houses and streets of his childhood housing estate using enamel-modelling paints on wooden surfaces. His faithful reproduction of detail and intense, accurate observation create an almost photographic quality to his work. His work is set above mundane photography by what he leaves out, what he doesn't say. There are no people in George's landscapes and no road signs or street architecture, which result in ghostly, derelict paintings fixed in time. George works with a camera first, patrolling the streets, taking hundreds of photos, looking for something that catches his eye, or evokes a memory from his past. The camera isn't merely a recording device; it is used as a translation tool, transcribing what he sees initially with his eyes into an idea for a painting. Whilst the quality of his outcomes (his paintings), are clearly highly skilful, it is this process of seeing and recording, of interpreting what he sees in a meaningful manner, that is of interest to both scientist and artist.

## Similarities and differences between the way scientists and artists observe

What most people mean by the term observation is simply everyday looking. In its purest sense observation is the act of seeing and recording, but these superficial terms alone are not sufficient when we talk about observation in science. The observational equipment the scientist uses to 'see' is not always visual and in addition many devices have been developed to record events that lie outside human perception; microscopes, telescopes, microphones, thermometers, x-ray and infrared cameras being obvious examples. So observation in scientific terms requires a broader definition than just looking and may be described as a discipline of rigorous analysis in order to record events, sequences and processes.

Scientific observation requires a disciplinary framework in order to identify the relevant information from the extraneous material. Scientists keep careful records of their observations in different forms, according to their discipline, that must be quantified and verified. From these observations, inferences are made which in turn lead to hypotheses that are tested by further experiment. Also, scientists usually return repeatedly to the cycle of observing, recording, testing and analysing in order to synthesise and reinterpret what they find. But ultimately, it all comes back to the

human mind (or minds) where this data and information is holistically interpreted and subjectified.

An artist observes and records their subject matter with similar intensity, but usually they are relying on their eyes and hands alone rather than using the vast array of equipment a scientist employs. This has implications that may be useful for teachers of STEM subjects, because they may feel that their students will become better practitioners through the development of a sharper eye with greater focus. The artist tries to hone, refine and adjust their outcome in order to attain greater clarity and this evaluative, intuitive process is strikingly similar to the scientists where they must select and reject information gathered in respect of its evidential accuracy in relation to a predetermined hypothesis.

In many ways this scientific process resembles realism in art, though the paradox is that for both disciplines, observation and personal interpretation can influence the resulting outcome. The observer affects what is being observed. The difference is that more expressive, abstract artists try to exploit and exaggerate these interpretations, whereas scientists are constantly struggling to overcome biases in what they observe in order to substantiate and validate their theories. Expression and aesthetic moves us away from the scientist's objectives, whereas realism moves us closer.

The Hyperrealists and scientists therefore seem to have similar objectives, both are constantly struggling for greater accuracy through observation. Given this similarity, it would appear that observational drawing could have beneficial effects on the scientist's practice. The artist's eye is clear and insightful, art teaches us how to look more intensely at the world around us, as well as giving the power to visualise with vivid clarity, all of which are useful scientific tools. The mistake a non-specialist might make is to believe that the outcome has to closely resemble the object of their drawing. Strangely, this isn't important. The important thing is to sharpen the sense of seeing, not the ability to coordinate the hand to skilfully interpret it.

In the preliminary stages of learning to draw, inexperienced artists fail to look intently enough. They focus their attention too much on the drawing process due to their anxiety about getting it 'right', instead of concentrating on looking at the subject matter. It is very similar to learning to drive where your attention wanders to the gear lever, the steering wheel or the pedals instead of looking at the road. As a result, many inexperienced artists resort to drawing stylised symbols of what they perceive is in front of them, the brain takes short cuts and the resulting outcome is not an observation but an imaginary reconstruction.

## Observational drawing exercises

(Please see the appendix for resources to accompany these exercises)

**Figure 2** *Magpie Sunset* by Paul Carney

Graphite on paper

The objective of these exercises is not to help you to draw better or more skilfully but rather to help you to perceive things more closely and attentively. Practicing these exercises regularly should help you learn more about the things you observe. Because our eyes only have a small central point of focus and a large peripheral vision, they scan subjects quickly and erratically to fill in the gaps of information in order to construct a coherent whole in our minds. Learning to draw from observation teaches you to see in a more orderly manner, slowly and deliberately building images with more clarity and depth. Observational drawing also improves our ability to remember and retain information.

## Doppelgänger drawing

One of the main barriers we face when we are learning to draw is that we don't look hard enough. We look at objects in short bursts but then spend most of our time looking at the paper in frustration. This exercise will get you looking at the object as much if not more than your paper.

Those of you of a certain age may remember using a wonderful drawing machine called a Pantograph. Invented in Renaissance times, it was a kind of criss-cross lever system that allowed you to make scale copies or tracings of drawings. They are out of fashion in this digital age, but are still available to buy. We are going to be using a similar process to the Pantograph method but only using our hands. Our non-drawing hand will trace the object and our drawing hand will mimic where it moves.

1. Print out a photograph from the resources provided or use a familiar object within arms reach such as a cup or a vase.
2. Place a finger from your non-drawing hand onto the image or object at a convenient starting point.
3. Now hold your pencil onto a piece of drawing paper with your drawing hand so that it is placed in an exact duplicate position.
4. Move your non-drawing finger around the image or object to trace its contours, and as you do so move your drawing hand in exactly the same way so as to copy and mimic the tracing finger.

It takes a little while to get used to and you have to tape any paper you use to the desk, but after a while both hands become coordinated and in sync with each other. What you should find is that, in time you only need to look at the object or image because you learn to trust that your drawing hand is moving in exactly the same way. This is an excellent way for non-sighted people to learn to draw.

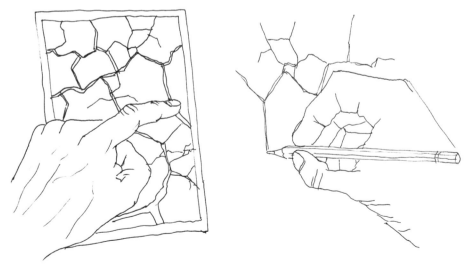

**Figure 3** Doppelgänger drawing

The non-drawing hand traces an outline and the drawing hand simply copies its movement. You learn to look only at the object and trust that the drawing hand will replicate it.

**Eye to Hand drawing (requires two or more people)**

Here a person (or persons) play the role of an unthinking, unconscious **'hand'** to draw what is described to them without being able to see the image or object themselves. The describer must play the role of the **'eye'** to instruct the artists as to where to move their hands, what lines and shapes to draw, what scale to draw them to and where to place these on the surface of the paper. They should help the 'hand' artists to correct and modify their work in order to perfect it. The 'eyes' are not allowed to instruct the person 'what' to draw, only how and where to move their hand. It is enormously challenging at first, but in time the artist learns to relax and trust the instructions being provided.

What is being learned here is the ability to communicate what is being observed, how to translate that information effectively and so enhance and sharpen the observation process. The artists learn to listen more attentively and follow instructions (whilst improving their drawing skills). In the process of describing, the describer develops not only the ability to give clear, oral instructions, but also learns how to look more intently. They see the image or object in a way they wouldn't ordinarily do, even if they were drawing it themselves.

**Instructions:** The artists must sit with their back to the describer who should be able to see what they are drawing at all times. The artists will set up with paper and drawing tools, whilst the describers must select an image for the artists to draw. You may select an image provided in this resource or choose one of your own (art teachers usually use famous works of art for this exercise). The describer then describes the subject matter to the artists who must carry out the describer's instructions in order to best construct the representation of the image. Consideration should be given to size and scale of the image, its position on the page and the shape and accuracy of the lines drawn. One rule though is that you are not allowed to tell the person what it is they are drawing!

**Figure 4** Eye to Hand drawing

The 'eye' in this exercise is the brain that instructs the 'hand' person where and how to move their pencil. The hand can't see the image but the eye should constantly guide what the hand is doing.

*Eye*

*Hand*

## Upside Down drawing

Making a direct copy of an upside down photograph is actually fairly easy, but whilst this improves your drawing skills, as an exercise in improving observational skill it is limited. Translating an object into a mirror image on your page however, requires you to make cognitive decisions about inversion and spatial awareness that are fairly difficult and therefore do improve your observational drawing skills. So instead of drawing the object or image the correct way up, your task in this exercise is to use your brain as a mirror and draw what you see in reflection on the paper. By doing this exercise, you are enhancing your observational ability because your working memory cannot process information as effectively. You have to constantly refer back to your subject matter with more frequency than you do usually and as a result you see the object in more depth.

**Figure 5** Upside Down drawing

Here I've sketched the photograph in reflection along the bottom edge. It is extremely challenging and forces you to look more intently at the image.

(Note: there is a variation on this exercise using a mirror, where the mirror is placed in such a way that the person can only see their drawing hand in reflection. This is a useful exercise, however its purpose is to test the asymmetry in the automatic functions of the hemispheres of the brain, not really in improving observation.)

**Instructions:** Select one of the accompanying images, choose your own or draw something from observation. Then make a line drawing representation of the object or image as though it was reflected in a mirror, upside down (or reflected in a left or right axis for example). When you become well versed in this skill, you might challenge yourself to draw an image in a 45-degree axis. It becomes extremely complicated and challenging when you do this!

**Further observational drawing exercises:** life drawing is simply the most complex, challenging and inspirational form of drawing, so if you are able, get along to a life drawing class. Failing that, keep a sketchbook or journal and draw things from observation as often as you can.

# Adapt

| 85 | 53 | 8 | 7 |
|---|---|---|---|
| **At** | **I** | **O** | **N** |
| astatine | iodine | oxygen | nitrogen |

## 3. ADAPTATION

- The process of adapting something or becoming adapted to a situation; adjustment, modification.
- A change that is made or undergone to suit a condition or environment.
- The process of adapting an artistic work from a different medium.
- An artistic work that has been adapted from a different medium.

<div align="right">(Wiktionary, 2018)</div>

### What is adaptation in science?

### Evolution

In biology, adaptation is the evolutionary process whereby an organism becomes better able to live in its habitat. It is one of the two main processes that drive evolution in species to help them enhance their fitness and survival ability. (The other is speciation, a process whereby a new species is formed from mechanisms such as geographical isolation.) Scientists and natural philosophers in the 18th and 19th centuries had begun to realise there was a connection between an organism and its environment (this had even been postulated in Ancient Greece). Building on the work of other pioneers such as Georges Leclerc and Jean Baptiste Lamarck, Charles Darwin developed a concept that organisms change over time as a result of natural selection.

Adaptation explains why organisms change; natural selection is the mechanism by which those changes are made. It answered questions that other natural historians had asked themselves for years; why some birds had elongated beaks whereas others had short ones, why animals that swim well have streamlined bodies or why some flowers were pollinated by moths and others by bees.

Adaptive traits have a functional role in the life of an organism as they encounter a series of environmental challenges in their growth and development. Structural adaptations are changes in an organism's physical features such as body shape. Behavioural adaptations are typically the ability to learn or alter behaviour to suit a changing environment such as searching for food. Physiological adaptations help an

organism perform other functions such as making venom or secreting slime. Without an organism's ability to adapt, none of us would be here to read this!

## BioBricks

eblink 4 More formation about obricks can be und here: tps://biobricks.org/

BioBricks are blocks of DNA that are used to design and assemble larger, synthetic biological circuits. Groups of people, known as 'bio hackers' take BioBricks with differing properties such as bioluminescence, or a blue colouring gene and play with them to assemble new biological organisms. There is even an open source, online BioBrick Foundation that standardizes biological parts and helps develop their educational expansion and exchange. It's a lot like a biological electronic circuit board, where instead of using capacitors, transistors and microchips, you combine DNA components to a base plasmid to create a sequence that forms a higher order system. BioBricks are fairly experimental at the moment, but are already being used to develop a wide range of prototype products; compounds to help protect honeybees from parasitic mites, biological ink to print organs for medical applications, transforming simple, sustainable chemicals into a universal source of fuel, and transforming bacteria into machines for sensing and degrading pollutants.

## Shinkansen Bullet Train

High-speed trains in Japan caused a particular problem when they emerged from tunnels. The build up of air pressure was so high from these trains that resulting sound waves produced a thunder clap that could be heard a quarter of a mile away. The trains caused especially bad noise pollution as well as pretty bad headaches for residents living nearby and so a solution was needed. However, a Japanese bird-watching engineer, Eiji Nakatsu, from the Japanese rail company JR-West, took inspiration from his favourite bird, the kingfisher to solve the problem. When the kingfisher dives into the water to search for food, its aerodynamic beak and body causes barely a ripple. By redesigning the nose of high-speed trains to resemble the shape of a kingfisher, he solved the problem and got a lot of thanks from the neighbours. The benefits of his design didn't stop there, it reduced power use and enabled faster speeds!

## What is adaptation in art?

### Marcel Duchamp

Weblink 5 More information about Marcel Duchamp and a selection of his works can be found here: https:// en.wikipedia. org/wiki/Marcel Duchamp

Readymade art is a kind of art pioneered by artist Marcel Duchamp in the early twentieth century as a reaction against purely visual, aesthetic art. 'Readymades' are common manufactured objects that become art merely because the artist has chosen them to be art and this instant, skill-less process of creation continues to provoke outrage to this day. Duchamp was an avid collector of manufactured objects he found interesting by virtue of their design. By placing them in a gallery as 'art' they became something entirely different. He was of course challenging us, provoking reaction, but at the same time he was genuinely trying to make us see everyday objects in the same way we do a painting or sculpture. They were scandalous at the beginning of the 20th century and still are. Famously, he turned a ceramic urinal on its back and signed it R. Mutt which was a pun on the German word for poverty. He also made what he called 'rectified' readymades. For example he drew a moustache and beard on a copy of the Mona Lisa painting by Leonardo da Vinci. Coat racks, combs, snow shovels, bottle racks, a bicycle and even 50cc of Paris air all became 'art' under Duchamp's auspicious hand.

### David Mach

David Mach is a Scottish installation artist and Turner Prize nominee who is a master of adaptation; he is a self-confessed 'materials junkie' who makes figurative sculptures from coat hangers, matchsticks, bricks, newspapers and even car tyres. In 1983 he created a sculpture of a Polaris submarine from tyres as a protest against the nuclear arms race. He has also made large scale sculptures of gorillas and other animals from wire coat hangers, figurative busts from matchstick heads, an enormous train from housebricks, and he combined huge swathes of magazine cuttings with vehicles and furniture to create vast abstract sculptural forms.

**Weblink 6** More information about Christoph Niemann and his work can be found here: http://www.christophniemann.com/

### Christoph Niemann

Christoph Niemann is a German born designer and illustrator who is most famous for designing the covers of the New Yorker magazine. Christoph is a master of the visual pun, inventing new meanings from familiar objects and photographs. He sees associations that most do not because he manipulates the properties of the world around him into new forms. In Niemann's hands, adaptation becomes child's play. He can weave elaborate images from almost anything, always with a strong sense of design and minimal information.

### How might we learn to utilise the advantageous properties of one material for another, more beneficial use?

The ability to see and recognise the properties of one thing and apply them in another situation is at the heart of human innovation. From the early prehistoric pioneers of medicine who saw that certain plants and organic compounds had healing properties, to modern pioneers of genetic modification, where organisms are altered in order to introduce a new trait that does not occur naturally in the species, adaptation is inherent to human beings. Nature of course is the real expert at adaptation as creatures evolve to meet numerous survival threats and selection processes in their environment. Human adaptation is usually of a more artificial, problem solving kind and so is heavily reliant on having increased knowledge about a system and being able to make associations and connections between unrelated, often distant, elements. The complexity of this kind of artificial adaptation lies in the fact that there is such a vast array of properties in the natural world to choose from, and it is unlikely that any one person is aware of the whole myriad of possible options. Clearly, increasing your knowledge of an organism will also increase your chances of being able to apply its properties to other areas. Art can't help you with that, but it might help you to know how to make more diverse applications of a process or system by teaching you to think more uniquely.

Improvisation exercises for example, which take you out of your comfort zone and plunge you into the icy pool of unfamiliarity, that if done regularly, enhance your cognitive ability to make connections between unrelated spheres. Performance art may appear slightly absurd and sometimes just plain ludicrous to some, but it has the potential to smash your known conventions, bend and twist your preconceptions and distort the familiar out of shape, which all enable you to 'see' in original ways and make those all important abstract associations.

However, there is also another kind of adaptation we use and that is the intuitive type. This is when we stumble upon the beneficial properties of something naturally or by instinct. This kind of adaptation comes out of humanities' inbuilt curiosity and ability to wonder. It may seem at first like this is a trait that cannot be taught, but ask any artist and they'll tell you that this is an inherent part of the process of making art. It's how we synthesise and fuse the properties of art materials together to create desired effects or play with them experimentally to see what happens. All innovators should develop this ability, but especially scientists and mathematicians, because this playful curiosity is how much innovation takes place. However, I won't discuss this any further here because it features in its own right in the 'serendipity' section (p44).

## Adaptive drawing exercises

(Please see the appendix for resources to accompany these exercises)

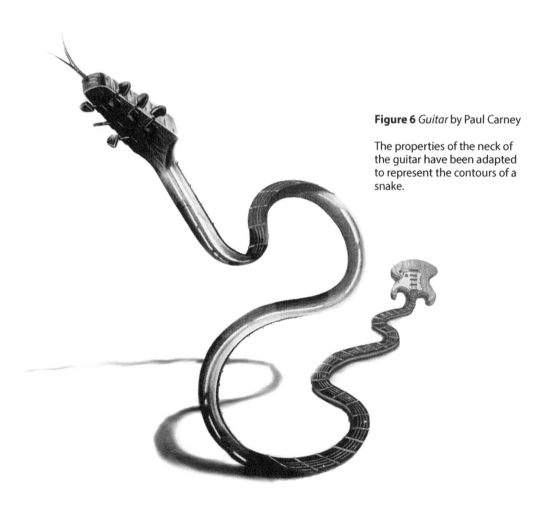

**Figure 6** *Guitar* by Paul Carney

The properties of the neck of the guitar have been adapted to represent the contours of a snake.

These exercises use drawing to enhance your ability to see the potential for adapting the properties of materials for other purposes. They are very creative and imaginative and some people (even those with good drawing skills) struggle to do them well at first. The reason for this is that most people don't need to use their powers of imagination very often and like any tool, its efficacy wanes if it is unused. So don't despair if you can't do them as well as you'd like, but alternatively, if you do this kind of exercise easily, then it suggests you have a greater imagination.

## Object adaptation

In this exercise you will select an object at random and be challenged to draw it as best as you possibly can. When you've done this, you have to use your realistic drawing as the starting point for another drawing from your imagination. You should build on, adapt, transform or manipulate the appearance of this first drawing to create a new image that can be anything at all. You might turn the first drawing into a character, an animal, a landscape, or even a pattern or abstract composition, this choice is yours!

For this exercise you'll need a selection of small, unusual objects to use as subject matter for the first drawing stage. A good place to get such items is from the odds and sods drawer that most of us have at home. You'll want things such as paper clips, clothes pegs, old batteries, springs, plastic covers, pen tops etc. All the weird kinds of scrap items that build up in our homes and offices. I've provided some photographs of these kinds of items for you to use while you build your collection. The digital versions provide you with the opportunity to import them into a drawing programme on a computer for digital manipulation or even to print them out and do the exercise as a quick starter activity where the students draw onto the copied version.

### Instructions
1. Select a small, scrap object.
2. Make a detailed study of the item from an interesting angle and as accurately as you can.
3. Transform the detailed drawing into an imaginative picture by adapting and manipulating the shape of the drawing to another purpose. Be imaginative, think of the whole surface of the paper and be original.

**Figure 7**
Here a simple drawing of a key has become an alien insect.

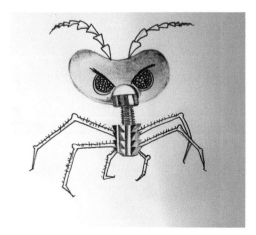

## Object improvisation

For this exercise you'll need to collect some more objects, only this time they do not need to be on such a small scale. You might use photographs of objects if it's easier, but I think giving the students the tactile sensation of holding and touching the objects helps produce better results. Great items for this exercise include; a ball, an old shoe, a scarf, a piece of sports equipment, a hat, empty bottles (glass or plastic), a sock, sunglasses, an old watch, a cup, bowl, plate or cutlery etc. The objective of the exercise is to reinvent the meaning of familiar objects into imaginative, creative purposes and so learn that objects can have different functions and purposes according to our interpretation.

### Instructions

1. Give the objects out randomly to the students and allow them time to familiarise themselves with them.

2. Next, give out the accompanying task to read:

   **"You may think you know what the everyday purpose of this object is, but what most people don't know is that it also has another, hidden purpose. You see, this object isn't what you think it is, it's something quite different, and it's something incredible, outrageous and impossible; something you would never have imagined in a million years. Although it has camouflaged itself very well, I can now reveal that this object is in fact….."**

3. You now have sixty seconds to invent an alternative idea of what this object might be, then you are to stand up for three minutes and tell the rest of the group what it really is. Be wild, imaginative, inventive, even preposterous or humorous!

4. Your next task is to create a drawing of your chosen object as the subject of your imaginative proposition. In short, record what you have just described as a drawn image.

## 4. COLLABORATION

1. The act of collaborating.
2. A production or creation made by collaborating.

(Wiktionary, 2018)

## What is collaboration in science?

**The Human Genome Project**
The world's largest collaborative biological project is the Human Genome Project or HGP (National Human Genome Research Institute, USA). Its goal was to determine the sequence of the more than 3.3 billion nucleotide base pairs that make up human DNA, and to identify and map all of the genes of the human genome. The HGP cost billions of dollars and was produced in twenty universities and research centres in the United States, the United Kingdom, Japan, France, Germany, Canada, and China. It was declared complete in 2003 and quality assured in 2004 though further analysis work is ongoing. The project aimed to identify the genetic variants that increase the risk for common diseases like cancer and diabetes, but it was far too expensive at that time to think of sequencing whole genomes. The scale of the task was daunting. This was a time when computer power was much more limited than it is today. In fact the first computerised, sequenced section of DNA was so big that it crashed computers. Later techniques sped up the process by breaking it up into base pairs. Today the results of the HGP are used by scientists as a reference database.

## Penicillin

Most people know the story of the discovery of penicillin. In August 1928, Alexander Fleming upon returning from a vacation with his family, reached his laboratory and saw that the Petri dishes he had left on his bench containing staphylococcus bacteria had become contaminated by different microbes from an open window. Fleming noticed that a fungus was growing and killing the bacterial colonies surrounding it. However despite his considerable efforts, Fleming found the antibiotic agent too difficult to purify and he lost interest in the process. It was the collaborative efforts of a team of Oxford scientists and US laboratories a decade later that made the essential breakthrough, not Fleming.

In 1939 Howard Florey, Professor of Pathology at the Dunn School, Oxford was appointed to head a team charged with developing an antibiotic drug. He brought in biochemist Ernst Chain, from Cambridge who persuaded Florey to investigate Fleming's findings. Florey employed a team of researchers including A Gardner, N Heatley, M Jennings, J Orr-Ewing and G Sanders and in 1940 the team was able to confirm Fleming's earlier findings that the mould inhibited the growth of bacteria. In one of their first experiments, eight mice were given a lethal dose of streptococci and four were given penicillin. The four mice that were not treated all died but the four mice that were treated with penicillin all survived for several days. It took several years of further, painstaking research, but thanks to the team's efforts and in particular Norman Heatley's manufacturing innovations, they were able to extract and purify penicillin, where Fleming could not.

However their work was far from complete. The next problem to solve was how to create large quantities of the drug and test it on humans. Heatley discovered that hospital bedpans were a good place to grow the mould so he commissioned a pottery company to make 1,000 square bedpans so he could manufacture the amount needed. This was not an ideal solution as it took an enormous amount of mould to create a small amount of penicillin and a large team effort was needed to harvest it. So the team went to the US and sought the help of the National Regional Research Laboratory in Illinois. After a worldwide search in 1943 they discovered that a cantaloupe mould contained the best strain of penicillin. Using a corn steep liquor fermentation process, the United States were able to produce 2.3 million doses in time for the Normandy Invasion of 1944. Injured soldiers were treated with the new antibiotic, making a major difference to the number of deaths and amputations resulting from infected wounds. Although Fleming received most of the credit, all he did was to make an important observation and record it. It was the collaborative efforts of the Oxford team and the American scientists who spent years developing penicillin which should receive the most attention.

Sir Henry Harris, who succeeded Florey as head of the Dunn School in Oxford purportedly said:

> 'Without Fleming, no Chain; without Chain, no Florey; without Florey, no penicillin.'
> (Harris, 1998)

## What is collaboration in art?

### Christine Borland

Turner Prize nominee Christine Borland is a sculptor who has worked in collaboration with other artists and with scientists from the field of forensic and medical science. Collaboration is at the heart of her making process and in her work *From Life* (1994) she worked with specialists in human genetics, medical artists and forensic anthropologists to study a human skeleton she had purchased from a medical supplies company. Using facial reconstruction, clay, plaster casting and computer generated imagery, she created a bronze portrait bust from the skull in an attempt to understand the unique, human characteristics of the anonymous object.

In another piece *L'Homme Double* (1997) Borland collaborated with six other sculptors to make busts of the Nazi war criminal Josef Mengele, known as 'the Angel of Death'. She gave the artists two grainy, black-and-white photographs of him and some written descriptions of his physical appearance from which to base their piece. What becomes obvious is that, despite the same starting point, all of the artists produce conflicting portraits, as though referring to the way in which human beings interpret the same information in our own, unique way. The busts were made from clay and left unfired as if to further emphasise the uncertainty of the figures' resemblance.

**Figure 8** *From Life, Christine Borland*, 1994

(By kind permission of Christine Borland)

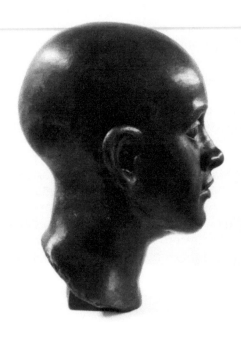

**Magna Carta tapestry**

Cornelia Parker is a contemporary artist who is well known for creating thought provoking pieces of art that transform, manipulate and even reinvent the meanings of objects that are familiar to us. She is a master of metaphor, symbolism and allegory who utilises a wide range of sculptural disciplines to make us critically reappraise current conventions about the known world. In 2014, she collaborated with two hundred people on a 13 metre tapestry of the Magna Carta's Wikipedia page to celebrate its 800th anniversary. She chose people who had been affected by the Magna Carta and who had relationships to civil liberty and the law, including politicians, MPs, lawyers, judges and even prisoners. The tapestry was commissioned in 2014 by the Ruskin School of Art in partnership with the British Library from proposals submitted by a shortlist of artists. A screenshot of the English Wikipedia article of the Magna Carta was printed onto fabric and hand-stitched, the majority done by prisoners, though celebrities and public figures also contributed words or phrases that had significance to them. Parker said she wanted to echo the symbolic importance of the Bayeux Tapestry in her work, but with emphasis on text rather than image. The tapestry was exhibited in the University of Oxford's Weston Library in 2015, where four of the original Magna Carta's engrossments are held.

## How might we teach people to collaborate more successfully?

Collaboration in science is vital. As the sheer scale and complexity of problems increase it is becoming more and more the case that significant innovations and breakthroughs in science are the result of a team effort, rather than individuals. Even when a single scientists name appears on a research paper or when they receive personal recognition, it is usually the case that a whole team of colleagues has supported the effort to a greater or lesser degree. Poor collaboration can and does get in the way of innovation. In the race to find the structure of DNA, two teams were especially competitive. The successful team led by Crick and Watson, won the day because of their strong professional relationship. The team that lost out, led by Maurice Wilkins and Rosalind Franklin, did so because of their fractious relationship.

It makes sense therefore, to develop strategies to enhance these collaborative qualities in people and to foster team-building strategies that make working in partnership more fluent. Most people don't work together naturally or instinctively. The skills of group working need to be taught and developed. We have to learn how to listen and respect each other's opinions, diffuse our irrational emotions and yet utilise them when needed. We are human beings first; whatever else we are follows.

Most scientists know that the most productive conversations happen in the bar or over a coffee. This is probably because the relaxed, informal atmosphere brings forward debate and opinion in ways that a classroom and formal lecture theatre rarely achieves. Now it may not be an ideal strategy to move your lessons to the pub, but you can't ignore the fact that people converse best when they are relaxed. It seems to me that you need to try to exploit this through the creation of informal discussion areas to facilitate higher quality debate.

Art activities are also a great way to bring people together, to share creative purpose in a fun, stimulating manner. Many successful artists produce work in collaboration. Jake and Dinos Chapman, Gilbert & George are prominent examples, and artists such as

Antony Gormley, Mark Wallinger and Jeff Koons employ whole teams of artist workers to synthesise and realise their creative intentions. But it may be true that other areas of the arts lend themselves more naturally to creative collaborative effort. Putting on a performance, a play or taking part in a musical group are valid ways of learning to become more effective team players and these should not be ignored. Collaboration in art can range from a whole community working to produce an installation, mural or sculpture, to a purposeful venture deliberately designed to blur the boundaries of individual ego or utilise specific qualities of the artists involved. Collaborative drawing is a great social, therapeutic experience that can be practiced on any floor, wall or flat surface.

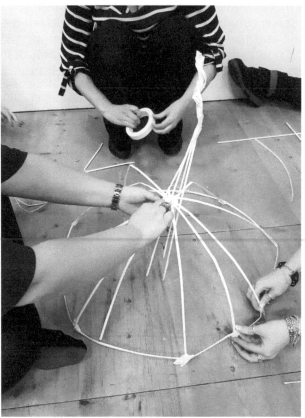

**Figure 9**
Group drawing with straws and masking tape to create architectural forms

## Collaborative drawing exercises
(Please see the appendix for resources to accompany these exercises)

Drawing is usually performed as a lone activity, but it doesn't have to be. Drawing is a great way to interact and socialise with people and is even a super icebreaker. These exercises attempt to develop students' ability to work coherently in a group situation.

### Group drawing
Three people per group are needed for this exercise. Give each person a black fineliner and a piece of tracing paper. Select an image from the ones provided in the appendix or choose your own. For greater accuracy, each person is to draw a box around the image to make sure they are working at the same size. You could even provide a line drawing of the image as a guide if it helps further.

## Instructions

1. Decide which of the group will draw horizontal lines, which will draw vertical lines and which will draw diagonal lines.
2. The group's objective is to shade the image using the kind of lines they have been assigned and no other; horizontal, vertical, diagonal.
3. Place the tracing paper over the image (you'll need three copies), with the outside box aligned and trace it using the photograph to help them describe the image using their chosen line type. Create tone in the image by drawing lines closer together to create darker shades or press more firmly with the pen.
4. Now overlay the three images to create a collaborative tonal drawing.

**Figure 10a** Drawing using only vertical lines

**Figure 10b** Drawing using only horizontal lines

**Figure 10c** Drawing with diagonal lines

**Figure 10d** Combining all 3 drawings as overlays

## Peg and pen drawing

This exercise takes collaborative drawing to the next level, because in this version, communication is everything. Each person will have different ideas about which direction they want to move and it can be very frustrating at first until you all learn to synthesise and coordinate your actions. You will need three or four people per group for this. You can draw any subject matter for this exercise, but I've included some images that I feel will work well in the appendix.

### Instructions

1. Place a large sheet of paper (at least A1 size) in the middle of a table or floor space.
2. Attach four strong clothes pegs to a felt tip pen, so that they point in different directions. Each person is to take hold of a clothes peg (preferably at the tip of one end rather than near the front).
3. At the first attempt, students are not allowed to speak and should place their spare hand over their mouth. Copy the selected image to fill the entire surface of your paper without leaving go of the clothes peg. At a suitable moment you can allow the students to begin speaking in order to demonstrate the power of communication.
4. For a further challenge; place a grid over the image and draw a corresponding grid on the A1 paper (but don't label the grid with numbers or letters). This will force the group to find the correct squares that relate to that section of image and draw them more accurately to the correct scale.

**Figure 11**
Peg and pen drawing

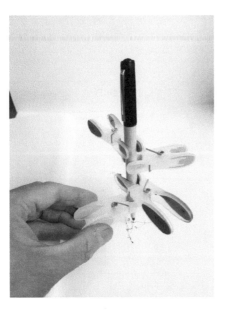

**Further exercises in collaborative drawing:** cover a table or floor space with large sheets of paper (decorative lining paper is good), and gather a few friends to draw an imaginative scene, a fictional character, a story or a whole new world. Talk and chat while you're doing it and don't worry about the quality of outcomes; in this exercise it's the process that counts.

## 5. KNOWLEDGE

1. The fact of knowing about something; general understanding or familiarity with a subject, place, situation etc.

2. Awareness of a particular fact or situation; a state of having been informed or made aware of something.

3. Intellectual understanding; the state of appreciating truth or information.

4. Familiarity or understanding of a particular skill, branch of learning etc.

5. Justified true belief.

6. The total of what is known; all information and products of learning.

7. Something that can be known; a branch of learning; a piece of information; a science.

(Wiktionary, 2018)

### What is scientific knowledge?

As we learn science and mathematics in schools and colleges we are studying 'facts' and 'truths' that have taken years to accumulate and that have been arrived at through a weighty process of review and verification. But we rarely study the processes that led to the innovations in depth. When we do what we learn are the triumphant proofs of concept and the successes, but perhaps it is the failures that might be the most revealing. It is only by examining the struggle, the frustration, the wasted efforts and the non-linear thinking patterns that led to the understanding, that we might learn how to innovate more successfully in the future, since every new theory requires reformulation of what has gone before it.

In addition, curriculum content isn't always as established as you may think. Textbooks have to be constantly revised in light of further research and quickly go out of date. Also, opinions differ, even between academics working in the same field. Often, scientists are working to 'best guess' scenarios using the information they have available. 'Facts' are usually quite precarious.

In the philosophy of science, knowledge is said to be either descriptive or explanatory. For example, students might learn to remember and recite descriptive facts that explain events, but it is another matter entirely to explain why they happened.

Mathematics uses a lot of deductive logic where certainty and proofs are accepted, whereas inductive logic, the logic of theory building, is the domain of science and is less certain. Inductive knowledge relies on a process called the Scientific Method where conjecture and speculation give way to observation, hypotheses, predictions, testing and analysis. Not all sequences are needed for every inquiry and they do not always follow the same sequential order, but the process essentially asks questions, gathers information, and then tests the results to see if they are verifiable. This then forms the basis of an empirical theory, which is the current understanding of the known information. Empirical evidence can always be upturned by new research.

The story of the dwarf planet Pluto is a perfect example of how scientific information begins as speculation, is transformed into a theory that is then rigorously examined, peer reviewed and then is finally revealed by new insights. Pluto's story shows us clearly how scientists must be cautious about the conclusions they draw from their early observations and also how knowledge changes in light of further investigation.

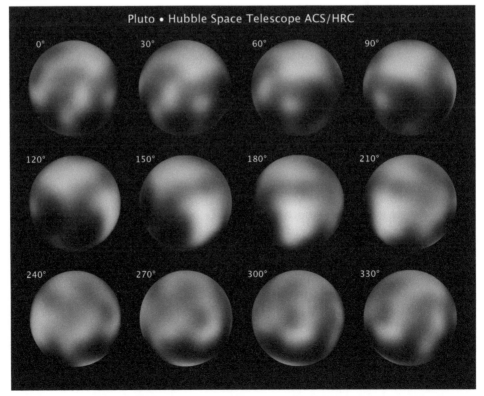

**Figure 12** A photomap image based on pictures of Pluto from 2002 to 2003 taken by the Advance Camera for Survey of the Hubble Telescope.

Image Credit: NASA

For over a hundred years there was speculation, argument and debate about whether this mysterious rock even existed, what its role was and whether to classify it as a planet in our solar system. For decades it was no more than a blurred white blob in a photograph until in 2015, the New Horizons spacecraft captured it in all its glory.

## Initial speculation

Observations in the late 19th century led astronomers to speculate that Uranus's orbit was being disturbed by another planet besides Neptune. American astronomer Percival Lowell spent the last decade of his life searching for the mysterious ninth planet, which he dubbed "Planet X". In March and April 1915, the Lowell Observatory managed to photograph Pluto, although the object remained unrecognised because the image was too faint. In fact, fourteen other prediscovery observations had been made as far back as 1909. At the time of Lowell's death, on Nov 12, 1916, Pluto still had not formally been found.

Weblink 7 More information about the discovery of Pluto and the work of the Lowell Obsevatory can be ound here: ttps://lowell.edu/ ne-story-of-pluto/

## Identification

The search for Planet X was suspended for ten years due to a legal battle between the Lowell Observatory and Lowell's widow over her husband's legacy. However, in 1929, Clyde Tombaugh, using a blink comparator, studied adjacent images of the night sky (a bit like Spot the Difference!), looking for movement between the plates that would indicate a planet. On Jan 23 and 29, 1930, after a year of painstaking study, Tombaugh spotted a small, faint object beyond the orbit of Neptune. Pluto had been discovered.

## Further information

In the succeeding decades after its discovery however, considerable doubt was cast on Pluto being Lowell's Planet X. Estimates of its mass were revised downwards and, due to more accurate measuring of neighbouring planets, the need for a Planet X to cause Uranus' orbital disruptions was quashed.

In 1978, American astronomer James Christy identified a satellite that travelled around Pluto once every six days. It was named Charon, after the ferryboat pilot who takes the dead into Pluto's domain in Greek mythology. In 1992, astronomers David Jewitt and Jane Luu discovered a second small, icy body in the neighbourhood of Pluto. Six months later, they had found a third.

From 1992 onward, the region of space beyond Pluto was observed to have a large collection of small, icy rocks that is now called the Kuiper Belt. Many scientists questioned whether Pluto was separate, or part of the Belt and further discoveries, including a satellite larger than Pluto called Eris, caused Pluto to be declassified in 2005 and renamed as a dwarf planet.

## Detailed inspection

In 2015 NASA's New Horizons space probe made a close flyby of Pluto. It revealed a wealth of information that few scientists had predicted. A distinct feature on Pluto's surface is a large heart-shaped region, the western lobe of which is a 1000 km-wide basin of frozen nitrogen and carbon monoxide ices that carry floating blocks of water ice in and out of the basin. Observations of Pluto's surface revealed mountains that reach as high as 3.5 km (3,500 metres or 11,000 feet) which scientists suspect are formed on a bed of water ice. No craters were visible on Pluto, which indicates it is

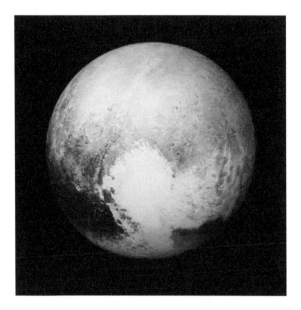

**Figure 13** Pluto taken from the Long Range Reconnaissance Imager (LORRI) aboard NASA's New Horizons spacecraft, July 13, 2015, 768,000 km (476,000 miles) from the surface.

Image Credit: NASA

less than ten million years old. It has an atmosphere of carbon monoxide, methane and nitrogen. It took over a hundred years, but in 2015 Pluto transformed for us from being nothing more than a mathematical theory and a blurry white blob on a page, into a stunning dwarf planet with incredible geographical features more amazing and spectacular than anyone had imagined.

## How is knowledge used in art?

Knowledge underpins everything we do in art. Knowledge isn't a list of facts or evidential information, it informs the choices and decisions we make and relates to the level of skill we have to execute our ideas. If creativity is the heart of what makes art then knowledge is the brains behind it, helping us to make choices, informing the process, helping us to evaluate, design and mould our ideas. It is easy to confuse knowledge in art with the history of art and artist makers, but it is much more than this.

It is often assumed that art as a subject of study isn't as knowledge-rich or academic as others (and therefore easier), but this assumption belies the fact that constructing original ideas and having the skill to execute them requires considerable amounts of dexterity and cognitive ability and these traits are knowledge too! Why else when we watch a skilled craftsperson at work do we marvel at how 'clever' they are?

Also important is the role information plays in our understanding of the art we see and this is where art as critical reflection comes into force. There have been many systems designed to help students observe art and the most common of these in schools is the Content, Process, Form, Mood method where students deconstruct art by identifying the artists' intentions and features of the artwork (Content), establishing how it was done and with what materials (Process), analysing how the artist has used the formal elements of colour, line, tone etc. (Form), and then surmising the emotions and feeling the work conveys (Mood). Whilst the complexity of this type of thinking does not compare to advanced scientific or mathematical thought, critical thought is nevertheless a skill in itself.

Like the story of the discovery of Pluto, revealing the artist's intentions or the social and political background to a work of art can radically alter our interpretation of it. Read this description of a piece of performance art by Fluxus artist Alison Knowles in 1962 called *Nivea Cream*:

> 'A performer comes on stage with a bottle of Nivea cream and pours some of it into their hands. They then massage their hands in front of a microphone. One by one other performers come on stage and repeat the actions. Next, they join together in a group hand massage. Upon a signal from the first performer they leave the stage in reverse order.'                                                                          (Knowles, 1962)

At first glance, this piece of art seems like an absurdity and you may be drawn into espousing some pretty negative opinions about the merit of this kind of art. However, if you remember the scientific principle of being wary about making early conclusions with limited information, then you may just hold back those opinions until you have more information. For example, if you were to have read *A Child's History of Fluxus* by Dick Higgins prior to the performance, then your understanding of the piece could be radically altered (even if afterwards you still thought the piece to be nonsense).

> *A Child's History of Fluxus* by Dick Higgins (edited version)
> 'Long long ago, back when the world was young – that is, sometime around the year 1958 – a lot of artists and composers and other people who wanted to do beautiful things began to look at the world around them in a new way (for them). They said: "Hey! – coffee cups can be more beautiful than fancy sculptures. A kiss in the morning can be more dramatic than a drama by Mr. Fancypants. The sloshing of my foot in my wet boot sounds more beautiful than fancy organ music." And when they saw that, it turned their minds on. And they began to ask questions. One question was: "Why does everything I see that's beautiful like cups and kisses and sloshing feet have to be made into just a part of something fancier and bigger? Why can't I just use it for its own sake?'
> (Higgins, 1979, used by permission of Hannah Higgins and the Higgins estate)

The explanation transforms the *Nivea Cream* piece into something more purposeful and we can now appreciate that the artist is attempting to translate something that to her is a profound experience. This is the basis upon which we form meanings from what we see; and this understanding is subject to change depending on what we know about it. Knowledge in art therefore, much more so than in science, is in a state of flux and constantly exposed to change.

## Is knowledge used in science in the same way as knowledge is used in art?

Knowledge plays a key role in establishing the authority of science in the wider society. We live in a rational world. People expect science to provide concrete answers, not vague, unsupported notions and in that sense scientists must be careful to emphasise which information is supported by evidence and which is not. However, elaborate speculation does have a place, even in science. Sci-fi writers, futurists and visionaries have provided humanity with many ideals that have become reality (moon landings, smart phones, robots etc.) and this kind of wild, creative thinking is an important part of the initial phase of inventing anything. Whilst the important thing is not to confuse

speculation with substantiated evidence, the wider your knowledge base is, the greater your chances of solving complex problems are. So even what might appear to be unrelated or even absurd at first, might just mould and shape your thinking later.

Scientists steer clear of stating they have 'proven facts' because they are fully aware that knowledge is transitory and relative. You may think the laws of gravity are facts, but they are only valid relative to our position on the earth and are more variable than you may think. Scientists don't 'prove' anything, scientific knowledge is empirical, that is to say it is knowledge that has been verified by observation or experiment. Empirical knowledge is subject to revision in the light of new information that overturns the previous position. You might think this would mean that science is always open to new ideas and fresh perspectives, but if anything the reverse is true, because it would become chaotic if anyone could come along and pull the rug from under a well-researched piece of information. Scientists have developed a practice of peer review, which means that new information must be critiqued and verified by other, independent scientists and the same results must be obtained, before it is rubber stamped as acceptable.

Science often walks a fine line between rigid process, imaginative speculation and outright error and it isn't always one it navigates successfully. Many successful inventions and discoveries have been rejected by mainstream science on the grounds that they were overly speculative or just wrong. Paul Boyer was met with disbelief when he first proposed that molecules in plants and animals produce ATP (adenosine triphosphate) in order to convert light, air, water and food into energy His first foray into this theory contained two major errors, but in light of peer review he was able to correct his work and, together with John E. Walker went on to win the Nobel Prize twenty years later in 1997. In 1964, Richard R. Ernst's work on a nuclear magnetic resonance (NMR) spectroscopy machine was rejected twice by the *Journal of Chemical Physics*. It went on to win him the Nobel Prize in 1991 (Ernst, 1991) There are many other examples such as these that show that ideas that challenge the established belief are not always received gladly.

Knowledge in mathematics is structured very differently to knowledge in art or science. Mathematicians aren't dealing with speculation but absolute certainty. Knowledge in maths only works if all the elements of its structure are aligned with one another.

This would imply that knowledge in maths is fixed and that creative thinking in mathematics irrelevant to all but professional mathematicians. But this is wrong. The ability to produce original ideas that extend the body of knowledge and provide insightful solutions does not suddenly materialise with the accumulation of more and more knowledge. To become creative mathematicians students should first understand the technical procedures that underpin the world around them, then they should learn the procedures in mathematics that are applied to perform mathematical techniques, before being able to make creative, non-algorithmic decisions themselves, (Ervynck,1991).

Knowledge in art can take several forms. It can be of a person, a time and place in history, a cultural event or an aesthetic object. But knowledge can also be a means to understand a process or a material. Knowledge informs the who, where, what, when

and why of what the artist does and how they do it. In this way artists use knowledge in the same way that the scientist does, to inform their process and practice, to help them make decisions about which action to take next.

As the artist works information is processed in the brain, then interpreted by the hand and then through the implement that they are using to make their art. What is represented in the process or outcome is not always the same as the initial mental projection and, in that sense, there is a disparity between what is intended and what is produced. There is a constant, ongoing decision-making process; a process of intention and realisation that is often extremely emotionally challenging to the individual. This is the artist's struggle, the battle to represent what is imagined or even the inability to imagine anything at all. Where the scientist seems almost besieged by curiosities and potential problems in the world around them, the artist must define their own, and there is alas, always that blank canvas in their minds that must be surmounted.

Contemporary art often replaces traditional art skill with a cognitive process. For these artists, the cognitive process (the knowledge and information) is the art. Harking back to Duchamp's 'ready-mades', today's artists play with ideas, codes, conventions, symbols and metaphors in the way that the old masters played with paint. They invite controversy and in doing so, force us to revisit notions that we might have once thought were resolved. These techniques are more than just superficial madness; they are a process that, if mastered, can lead to new applications of common understandings. After all, originality does not comply to current orthodoxy, and expectation needs to be challenged if you want to discover something new

## Drawing exercises to help develop students' understanding about scientific knowledge and information
(Please see the appendix for resources to accompany these exercises)

### Knowledge exercise
This exercise attempts to clarify in student's minds the differences between types of scientific knowledge and in this respect it may be more suitable for older students. Hopefully it should help clarify the differences between speculation, hypothesis and theory in a visually impactful way.

1. Students are shown a diagram of the front of a house (Figure 14). Using it to help them, they must create a drawing of what the **back** of the house looks like. Record lines they have a 'high degree of confidence' about in one colour and then make speculations about the type and position of other details in a different colour. Together, these lines form their hypothesis of what the back of the house looks like.
2. Peer review; the students should exchange their drawn theories with other students and subject them to analytical discussion for further modification.
3. Students are now given more data that shows internal views from inside the house. Using this additional data, can they revise their hypothesis to form an updated theory about the back of the house?
4. Peer review; the students should exchange their drawn theories with other students and subject them to analytical discussion for further modification.

5. The students should now speculate as to what else might be at the back of the house e.g. garden furniture, plants, conservatories etc.
6. Peer review; the students should exchange their drawn theories with other students and subject them to analytical discussion for further modification.
7. Now show the drawing of the actual back of the house and discuss.

**Figure 14** Here is a drawing of the front of a house. But can you use it to help you draw the back of the house?

### Draw what's in the box
(Please see the appendix for resources to accompany these exercises)

Knowledge in science is nearly always taught retrospectively, i.e. after the information is verified. But this isn't how knowledge is formed in science. Usually things are only part known, some information is missing and some information is misleading. Mathematicians might find this exercise very odd, because their logical approach to problem solving will not be relevant here. Such is the nature of creativity!

This exercise is designed to demonstrate to students the complexity of making inferences from the information available. I've tried to replicate the way in which information is often built up in science, in that information is received piece by piece, in isolation, like clues rather than holistically. Hopefully, it will also illustrate to students the dangers of making rash conclusions from gathered evidence and demonstrate that not all information can be trusted.

In this game, the students must try to deduce an item hidden in a box by making drawings from the clues given. The clues are designed to lead them to a particular answer that will be only partly correct because it is virtually impossible to deduce the

exact nature of the object from the clues. I've also tried to make the clues deliberately misleading in some instances, to confuse the students and to show them that some information is not relevant and sometimes the information you get is wrong.

**Instructions**
1. The students are shown a photograph of a box (you might also use a real box for this), and are told that they must try to deduce what is in the box from a series of clues.
2. One person (usually the teacher) reads aloud a series of clues. After each clue is read the participants must draw what they think is the answer and hold it up in the air. Several sheets of paper will be needed therefore, or small whiteboards and pens. You might even fold a sheet of A3 paper into 4 sections.
3. At the end of the game most people by now should have several drawings, one of which they must choose as their answer. The teacher reveals the object.

**Figure 15** Draw what you think is in the box using the clues provided.

4. Can the students explain what information is missing? How would a more accurate description of the object differ from what they had gleaned from the clues? Perhaps they could write further clues for the game that would enable future players to get a more accurate answer.

See attached handouts for clue cards

**Further exercises in knowledge:** read as much as you can about how different artists worked and why they worked in the way they did. Learn how the great artists used drawing to help them realise ideas and rationalise their thinking. Use this new knowledge to expand your own repertoire of drawing practice. Adopt their techniques and modify them to suit your own ideas and intentions.

# serendipity

## 6. SERENDIPITY

- An unsought, unintended, and/or unexpected, but fortunate, discovery and/or learning experience that happens by accident.
- A combination of events which are not individually beneficial, but occurring together to produce a good or wonderful outcome.

(Wiktionary, 2018)

### What is serendipity in science?

'In the fields of observation chance favours only the prepared mind'
(Louis Pasteur 1854)

### Cosmic Microwave Background Radiation

**Weblink 8**
More information from NASA about cosmic background radiation can be found here: https://map.gsfc.nasa.gov/universe/bb_tests_cmb.html

In 1964, Arno Penzias and Robert Wilson were trying to measure faint radio waves with a supersensitive, 6 metre antenna in Bell Laboratories, New Jersey, USA. However, when they studied their data they found a persistent, low, steady, mysterious noise. It was a hundred times more intense than they expected and was evenly spread over the sky, night and day. Convinced that it did not come from anywhere in our galaxy, they at first thought it might be an anomaly caused by their equipment, so they thoroughly cleaned it from nesting pigeons and their droppings, taped over every seam and rivet and tested and cleaned every plug and circuit, but the noise remained.

Unknown to them at the time astrophysicists at Princeton University, just 60 km away were looking for the very thing they had found. What they had discovered was background radiation scattered in the Big Bang at the beginning of the Universe. A colleague told Penzias about the research at Princeton and they invited the astrophysicists over to listen to their background noise, which they immediately confirmed as a signature of the Big Bang. To avoid potential conflict, they decided to publish their results jointly. In 1978, Penzias and Wilson were awarded the Nobel Prize for Physics for their joint discovery.

### Microwave Oven

A scientist's sweet tooth led to the discovery of another device we see in most homes today. During World War Two, scientist Percy Spencer from the American Raytheon Company was inspecting a magnetron (a type of energy tube used to power radar). Whilst standing in front of the device he noticed that a chocolate bar in his pocket had melted. Intrigued, he tried other foodstuffs, (including popcorn) which in turn led to him developing a microwave-cooking machine that was first patented in 1945. The first commercially available microwave oven was 1.8 metres tall, weighed 340 kilograms and cost over £2,000!

### Heart Pacemaker

In 1956, whilst working as an assistant professor in electrical engineering at the University of Buffalo, Wilson Greatbatch stumbled upon a life changing discovery. He was trying to develop a heart-rhythm recording device when he accidentally grabbed the wrong transistor and installed it in his device. Realizing his mistake, Greatbatch was still curious to see what would happen and he was surprised to discover that the circuit it produced emitted intermittent electrical pulses, similar to those of a human heartbeat. He began experiments to make his device smaller and protect it from bodily fluids. In 1958, doctors at the Veterans Administration hospital in Buffalo demonstrated that his device could take control of a dog's heartbeat.

However Greatbatch soon discovered that he was not alone in his quest to develop a heart pacemaker. Other researchers were making similar devices around the world. So he used his savings to convert a barn at his home and went to work full time on his device. In 1960 it was successfully implanted into ten human patients and in 1961 his heart pacemaker was licensed to an American company who went on to become the global leader in cardiac stimulation.

## What is serendipity in art?

In art, serendipity is the 'happy accident' with the medium, or the employment of carefree, uncontrolled ways of working such as unconscious, abstract drawing and painting. As I said earlier, serendipity is an inherent part of the process of making art. It is how we synthesise and fuse the properties of art materials together to create desired effects or play with them to see what happens. It is also strongly related to improvisation in other areas of the arts, such as performance, comedy, music or dance.

### Marcel Duchamp

Weblink 9 More information about Marcel Duchamp and his *3 Standard Stoppages* (1913-14) can be found here: ttps://www.moma. rg/collection/ orks/78990

In 1913, and after receiving critical acclaim (and also much criticism) for his work such as the now famous *Nude Descending a Staircase*, French artist Marcel Duchamp gave up painting as being 'washed up' and began working as a librarian. He had been so moved by the beauty and complexity of new technological innovations (in particular an airplane propeller) that he began studying maths and physics and developed a fascination for engineering, philosophy and science. In particular he was influenced by the brilliant French mathematician and physicist Henri Poincaré, famous for proposing gravitational waves, founding the principles of topology and chaos theory, and for providing the mathematical framework for Einstein's theory of special relativity.

Poincaré's chaos theory stated that within the apparent randomness of chaotic systems there are underlying patterns and these theoretical writings had a profound impact

on Duchamp. He began experimenting with art and science by integrating aspects of Poincaré's ideas into his sculptures. He made his piece *3 Standard Stoppages* in 1913 by dropping three, one metre lengths of thread from a height of one metre onto a blue-black prepared canvas in random positions. Then he varnished them into place, preserving the random curves they had made, which further served as templates for draftsman's edges, which he cut from wood. The accidental curves created by the string became a subversion of a standardised unit of measure.

How much Duchamp understood of Poincaré's theories is unclear, but what is likely is that the three shapes represented in his piece are a reference to Poincaré's three body problem and the placement of the threads not only exploit chaos theory but also the non-Euclidean geometry problems with which Poincare was wrestling. What Duchamp does through his art is to channel Poincaré's theories and philosophies into symbolic, visual metaphors laced with humour.

### Dadaism

**Weblink 10**
More information about Jean Arp and his *According to the Laws of Chance* (1933) can be found here: https://www. tate.org.uk/ art/artworks/ arp-according- to-the-laws-of- chance-t05005

The idea of manipulating chaos and playing with random events was further elaborated by Dada artists Hans (Jean) Arp and his partner Sophie Taeuber after the First World War. Arp began experimenting with the 'laws of chance' by ripping up his drawings and throwing them onto the floor, gluing them into the positions they fell. This developed later into cutting the paper and card with a guillotine in order to remove as much human control from the process as possible. Arp himself described it as being guided by the work without consciously controlling the forms. He even likened it to something being born. Later, his torn collages were requested for an exhibition by a major gallery. However, upon retrieving them from his attic he found to his horror that the work had deteriorated from exposure to the moisture and humidity. His shock at seeing the rotten paper, dissolved glue and smeared ink soon gave way to revelation though as he realised that nature had contributed to his work. From then on he began to tear up his works, smear them carelessly with paste and facilitate greater natural deconstruction. The concept of the autonomous, uncontrolled process of making art had begun, to be picked up later by artists such as Salvador Dali and John Cage.

## Can we teach people to be more fortuitous; to have more flashes of inspiration, or 'a-ha' moments?

When trying to identify the factors that bring about serendipity it is important to understand that chance events such as these are the outcome of a controlled process; they happen within orchestrated parameters and come from systems that facilitate or encourage the possibility for unconscious thoughts and actions to manifest themselves. For example, random mutations of DNA come from the shuffling of two very specific genetic decks within the highly ordered process of reproduction, not from outer space. The 'a-ha' moment or flash of inspiration might seem to come from nowhere, but this is evidently not the case.

Order, organisation and methodology are all important attributes for good science, but so are inquiry, curiosity and investigation. Scientists and mathematicians must ask themselves, 'I wonder what would happen if…' in much the same way as an artist does and in that regard they are similar. The danger for science is when they may restrict or limit this natural curiosity by emphasising too much rigour, too early. There is a strong case for both and science is always trying to balance these opposing elements.

What is certain though is that serendipity isn't a sudden, chance event. It comes out of deliberation, consideration and struggle. In fact scientist Henri Poincaré wrote extensively about his own creativity and how his insights came about. Specifically, he describes a process of long, intense frustrated study that preceded his sudden insights:

> 'I turned my attention to the study of some arithmetical questions apparently without much success and without a suspicion of any connection with my preceding researches. Disgusted with my failure, I went to spend a few days at the seaside and thought of something else. One morning, walking on the bluff, the idea came to me, with just the same characteristics of brevity, suddenness and immediate certainty that arithmetical transformations of indefinite ternary quadratic forms are identical with those of non-Euclidean geometry. '     (Henri Poincare, 1914: 53-54)

The artist that is deliberately experimental and playful will likely bring about more opportunity for 'happy accidents' to occur than those that aren't and the same is true in science. However, many artists find the developmental process of open, experimental synthesis of materials to be difficult. It comes naturally to some, who appear to be more instinctive, adventurous and carefree with their manipulation of media. Others struggle to find this level of freedom and seem anchored by anxiety, convention and fear of making mistakes. But it is wrong to think you are consigned to a 'type' and that you can't develop these skills. You can, you just need to practice opening your mind through bold, experimental creative exercises, some of which I've outlined below.

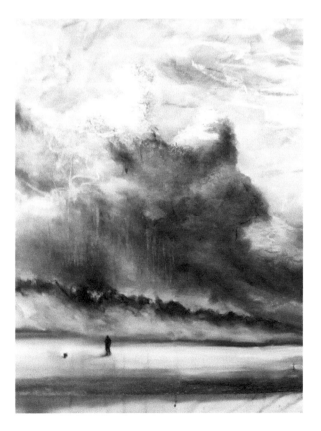

**Figure 16** *Storm* by Paul Carney

Part of the success of this drawing lies in the accidental dripping of water and the manipulation of the fluid nature of the media.

## Serendipity drawing

You'll need A4 and A1 white paper, string, a few straws or sticks, scissors and some random objects such as curtain rings, CD boxes or anything with a strong shape for this. To draw with you'll also need black (or coloured) ink and watercolour brushes, and a spray bottle filled with diluted ink. (You can buy these from a pound store.)

1. Using the scissors and A4 paper, cut out (or rip) some random shapes. They can be large or small, straight or jagged, organic or geometric, but they must be abstract.
2. Standing at a height over the A1 paper, drop the cutout shapes randomly on the surface. Don't think too much about it or try to control the outcome, just let it happen naturally.
3. Now drop other shapes on to the paper such as pieces of string, sticks or straws and the random shapes you found. Again, don't overthink it.
4. Use the spray bottle of ink to spray over the objects and areas of the paper, and then remove them to leave silhouette shapes.
5. With the ink and brush, draw into the empty spaces using abstract lines and shapes.

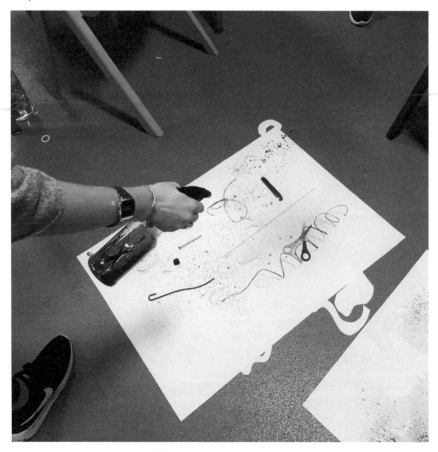

**Figure 17** Serendipity drawings using controlled chaos

### Further exercises in serendipity

1. In a group, each should quickly sketch a random line on a piece of paper. Collect them all in, shuffle them, and then give them back out so that no one has their own doodle. Begin transforming the photocopied doodles into more formalised drawings by adding additional lines, detail and shading. After a few minutes, pass the drawings around the circle to develop the drawing. Keep doing this until they are complete. Evaluate the results to identify which have worked and which haven't.

2. **Abstract autonomous drawing:** Begin by clearing your mind of all thoughts for a couple of minutes. Next try creating pictures from random marks or accidents on a page. Create drawings from the marks left by a previous drawing on the next page or throw some art materials randomly on a page then begin working it into a drawing.

3. Throw string randomly onto paper from a height of two metres, then take a rubbing of the resulting pattern. Transform these rubbings into art forms using either photography, or by adding other media, colour, lines and details.

**Figure 18** Abstract autonomous drawing by Paul Carney

In this exercise, you clear your mind of conscious thought by meditating for a few moments, then pick up your art materials and draw without trying to control the outcome.

AATT**M**ACTGATAA
CGGCATTTAAGCTA
TCG**E**TTTACGTACG
ATCCGGAA**T**TAC
GT**R**AGCATCGGTA
AAGC**H**GCATATCG
ATCGACT**O**ATAAC
GGCAT**D**TAAGCTAT
CGATTTACGTACGA
TCCGG**IA**TTTACGT
**R**AG**C**ATCGGTAAA
GCTGCATATCGATC
GACTGATAACGGC
ATTT**A**AGCTATCGA
TTTACGTACGAT**LC**

## 7. METHODICAL

- In an organized manner; proceeding with regard to method; systematic.
- Arranged with regard to method; disposed in a suitable manner, or in a manner to illustrate a subject, or to facilitate practical observation.

(Wiktionary, 2018)

### How do scientists use methodical, systematic approaches to innovate and discover?

#### Nematode Worms

By 1980, many scientists had tried and failed to map the embryonic cell stage of nematode worms using photography. So in 1981, scientist John Sulston working with Sydney Brenner and Robert Horvitz decided to study their evolvement by hand. Years of research culminated in intensive observation. He worked alone, in silence observing the worm cells through his microscope, eight hours a day for eighteen months, cataloguing them dividing by drawing pictures as he looked. Sulston drew the positions of the cell nuclei, using colour to indicate the different layers of cells: red for the top levels, green for the middle, and black for the bottom.

He then needed to work out why they behaved as they did, which meant sequencing their genes. He had to go through x-ray images of every gene and painstakingly identify and label them with a pen: TTAAA, AGCTT, CGAGA, GTCT, AACA etc. Each gene image was composed of columns and columns of black and white patterns, where each main column had four individual columns. Once he had sequenced the nematode worm the scientific community knew they could sequence the human genome.

**Figure 19** Notebook page

Copyright John Sulston, with kind permission of the Wellcome Collection

## Pulsars

Whilst a postgraduate student at the University of Cambridge in the late 1960s, Jocelyn Bell Burnell worked with her supervisors for two years to build a radio telescope to study quasars. Her subsequent work involved reviewing as much as 96 feet of paper-printed data per night, and in the process she detected a 'bit of scruff' on her chart recorder papers. This was a signal from deep space that was pulsing at a regular rate of about one pulse per second. Her supervisor Antony Hewish was sceptical and dismissive about her find and insisted that the anomaly was a result of human interference. Despite being snubbed from department meetings she persisted; precisely observing, recording and reporting this new phenomena known as a rapidly rotating neutron star, or pulsar, until eventually they conceded she was right. Unfortunately for her, it was her supervisor, Hewish who took all the credit and in 1974 he was awarded the Nobel Prize in Physics for the discovery. She herself was not upset by this at all and modestly stated that it was only fair that he, as course leader should be credited (Burnell, 1977).

## Insulin

In 1958, British scientist Fred Sanger at Cambridge University solved what had seemed like an insurmountable problem by revealing the structure of an insulin protein. The sheer size and complexity of DNA molecules were originally thought to be indecipherable but Sanger won the Nobel prize for his painstaking, laborious work which led to the artificial creation of insulin and the treatment of diabetes. Using an approach he called the 'jigsaw puzzle method' he broke insulin molecules into smaller sections for analysis then fitted the pieces back together. The process was agonisingly slow. So slow it took him ten years to identify the complete structure of insulin!

Next, he turned his attention to the individual genes contained in DNA. He was at first dismayed by the scale of the problem and he quickly realized his 'jigsaw puzzle method' wouldn't work. However, through sheer persistence he eventually developed a more efficient approach that enabled 500 to 800 letters of DNA to be printed on to photographic images. Now known as the Sanger method, it vastly increased the speed at which DNA could be read, but he still had to laboriously go through thousands and thousands of bases to study, label and separate them by hand. This process was the principle method of reading DNA for 39 years and was speeded up using computers, but it has now been replaced by more efficient techniques.

**Weblink 11**
More information about Georges Seurat and his *Seated Nude: Study for 'Une Baignade'* can be found here: https://www. nationalgalleries. org/art-and- artists/19740/ seated-nude- study-une- baignade

## How do artists use methodical, systematic approaches?

### Georges Seurat

Georges Seurat was intent on using the then new scientific theories of colour to make his paintings seem brighter and more colourful. Rather than mixing paint in the palette, he used pure colour from the tube in small overlaid dots to avoid the 'muddiness' you often get when colours are mixed. The effect of this was to converge the pure colours in the eye and brain to create an illusion of mixed colour. We still use this process in modern printers, where three primary colours and black create almost every variation of colour we can see. For Seurat this was an enormously time consuming and intricate process. His painting *A Sunday Afternoon on the Isle of la Grande Jatte* is huge; 207.6 cm × 308 cm (81.7 in × 121.25 in), and took two years to complete! Now

known as Pointillism, he began by doing lots of sketches outside in the park (these sketches were still done by painting in dots). When he was satisfied he began the canvas. He would work everyday, in ten to twelve hour shifts, painting minute dots and overlaying them meticulously to create his effect.

Yet Seurat's drawings were only slightly less meticulous. Undeterred at having been graded at 77th out of 80 by his art teachers in his drawing class of 1887, he went on to develop another novel technique of drawing where he abandoned the use of formal outlines and instead focussed on depicting the tonality of form. Through the use of delicate layers of fine crosshatch with conté crayon on a woven Michallet paper, Seurat creates haunting images bathed in light and dark contrasts.

> 'They (the viewers) see poetry in what I have done. No, I apply my method and that is all there is to it'                                                            (Rewald, 1956: 86)

## Mark Wallinger

**Weblink 12** More information about Mark Wallinger can be found here in the Baltic Gallery's learning resource: http://baltic. art/uploads/ Mark_Wallinger_ Learning_ Resource.pdf

In his piece *10000000000000000*, Mark Wallinger places 65,536 stones onto 10,024 chessboards. The number used in the title of the work is the binary equivalent of the number of stones and squares used, which is in itself a superperfect number, the result of two to the power of sixteen. In his work, the usually chaotic arrangement of stones (on a beach for example), has been reordered mathematically and methodically using the chessboards. There is a stark contrast between the infinite variety of the stones' shapes and the uniform precision of the black and white grid. Wallinger describes the thinking behind the work as coming from playful intuition that developed into the notion of cataloguing the stones as an archaeologist might. He became aware of the significance of the number 65,536 in early computing (the first 16 bit computer could store $2^{16}$ different values) and the relationship between artificial intelligence and the human mind. Ultimately, he says, it is about making us look at the stones more intensely.

Other works by Wallinger use similar, methodical approaches. In *The Other Wall* he painstakingly, individually numbers thousands and thousands of household bricks then lays them in a random sequence to create a huge wall, with the effect that each brick gains a unique identity. In *State Britain* he faithfully recreated peace campaigner Brian Haw's forty metre Parliamentary protest banners, photographs, flags and messages. *State Britain* was led by Michelle Sadgrove at Mike Smith Studios and employed fifteen artists from various artistic backgrounds over a period of six months. They used Wallinger's 800 photographs to recreate over 1500 objects for the display.

## Marina Abramović

In her 2010 work *The Artist is Present,* Serbian performance artist Marina Abramović sat in a gallery space at the Museum of Modern Art in New York every day for three months without moving or speaking, inviting spectators to sit opposite her and hold her gaze. Approximately 1500 visitors took up the challenge over the 700 hours she sat, seven hours a day without rest or breaks. Only one man matched her and sat for a full seven-hour session. It was an incredible feat of mental endurance.

## Can we teach methodical systematic approaches and if so, how might they be best learned?

Rather than in a sudden leap of insight, the more usual way innovation occurs is through concentration, focus and the hard slog needed to wade through enormous amounts of information to find that vital piece of evidence. Data crunching for example, is painstaking, tedious and unglamorous, yet it is an essential aspect of a scientist's work. Computers have speeded up or even removed many of these tedious processes, yet the need for hyperfocus or flow as it is more positively known, is still just as prevalent. The perception that only highly intelligent, genius types can effect innovation is somewhat mythical. Yes they exist, but more often than not innovation comes from poring over laboriously collected data, processing it and methodically analysing the results before formulating a hypothesis that is then itself rigorously scrutinised. And in any case, even when sudden insight does occur, the evidence to support it is always gathered through more mundane means.

Like any approach, methodical approaches need to be taught, because we are not starting from a level playing field. Some people might have a more structured, organised way of thinking than others, and they may have more inherent patience, but that does not imply that people with a tendency toward associative thinking styles cannot and should not, learn alternative methods. Professor Frank Coffield's research at Newcastle University (2013) put to rest the idea that we are tied to a single learning style.

The act of studying anything complex over long periods of time, as students do, might be taken as mental training in the development of methodical approaches. But by repeatedly practicing focused exercises in concentration, we can develop our ability to apply our minds in a much more coherent manner. Many people practice meditation to achieve this effect, but rigorous drawing activities can achieve much the same thing and (in my opinion) be more enjoyable. Just by drawing, and drawing often, over long periods of time we can learn to focus our minds to achieve the same methodical discipline needed by many scientists. I think it is that simple.

### Methodical Drawing Exercises

(Please see the appendix for resources to accompany these exercises)

Any, long continuous drawing process will develop these skills. Remember, it's not uncommon for an artist to spend weeks or even months working on the same piece every day. This is a painstaking process (you get a good idea of what Sulston did in his work), and it is a good indicator of what much of the practical, day-to-day experience of science is about; methodically and accurately recording data into organised patterns.

**Figure 20**
*The Watcher* by Paul Carney

This drawing belies the level of concentration
needed for this piece. Apart from being
mathematically challenging, every brick is
rendered with three layers of tone and drawn
individually. It took 3 weeks to draw but that is
nothing in comparison to Sulston's work.

## Methodical drawing exercise 1

For this exercise you'll need a sheet of A4 writing paper and a pen. First, you'll need to invent five simple symbols. Try not to use letters or numbers, but keep them simple. Now, I'd like you to write the symbols on the first line of the A4 paper. Keep repeating the five symbols until you fill the page. You should use every symbol once in the sequence. The rule is that the last symbol of a sequence cannot be the first symbol of the next sequence. Do not insert spaces each time you repeat the five symbols. Begin a new sequence on every line.

What is the point of doing this? Well, as soon as our brain learns to do repetitive tasks it moves them into autopilot, allowing you to think of what you're going to have for your dinner. True concentration requires focus. So if you want to improve your levels of focus then you have to do tasks that require ongoing thought. This repetitive task needs your constant attention because you have to keep checking that you've drawn all the symbols in the sequence and you're not repeating the last and first symbols. It's also difficult to keep drawing the same symbols over and over. Look at my example and spot the mistakes! If you find it too hard, reduce the number of symbols. If it's too easy increase them.

**Figure 21** This pattern based exercise needs your constant focus because you have to check your accuracy at every sequence.

## Methodical drawing exercise 2

In this exercise, the students must draw a series of small, similar looking objects (but not identical) in the manner of recording and cataloguing them. I've chosen raisins in my example, but other objects could be selected such as popcorn. Anything that is similar, but unique in appearance will do.

Draw a grid large enough to accommodate the items you are drawing or use squared paper. In this example, my grid is 10mm square.

Begin selecting items at random then draw them carefully.

Focus and concentrate to describe the unique features of each object.

I've drawn eighty raisins here. Could you draw more? How about eight hundred? Or eight thousand?

Can this exercise be modified or improved in order to later identify the raisins after they have been drawn?

**Figure 22**

alternative viewpoints

## 8. ALTERNATIVE VIEWPOINTS

'The position from which something is observed or considered: an angle, outlook or point of view.'

(Wiktionary, 2018)

'During the time that [Karl] Landsteiner gave me an education in the field of immunology, I discovered that he and I were thinking about the serologic problem in very different ways. He would ask 'What do these experiments force us to believe about the nature of the world?' I would ask, 'What is the most simple and general picture of the world that we can formulate that is not ruled by these experiments?' I realised that medical and biological investigators were not attacking their problems the same way that theoretical physicists do, the way I had been in the habit of doing.'                          (Linus Pauling, 1958: 234)

### How have alternative viewpoints led to innovation in science?

#### Conflict

**Weblink 13**
More information about Alessandro Volta can be found here: https://www. famousscientists. org/alessandro-volta/

Perhaps one of the most emotional ways of developing ideas and theorems is through debate and argument. Scientists are people first and there's nothing quite like an opposing viewpoint to make you sharpen your case and strengthen your argument. In fact, it's possibly essential to do this to any newly thought out hypothesis, in order to make it more rigorous and save yourself a lot of time. These challenging questions can be difficult to see in the moment of excitement and exhilaration of discovery and so it is often left to outsiders, even rivals to make you see your flaws. This happens all the time and there have been many notable debates, not least of the debate between religion and science, especially via evolution.

One story that caught my mind was the famous Galvani vs. Volta debate of the 18th century. Galvani, a religious man and Benedectine member of the Academy of Sciences in Bologna, coined the term animal electricity to describe the movement of a dead frog's leg when touched with an electrical charge. He believed the activation was generated by an electrical fluid carried to the muscles by the nerves. However his intellectual adversary Alessandro Volta disagreed. Volta peer reviewed Galvani's experiments and eventually came to a different conclusion. He began to believe that the muscle contractions were caused by the metal cables used to connect the muscles and nerves. He argued that the animal electricity was a physical phenomenon caused by rubbing frog skin (static charge) not a metallic electricity.

Galvani believed the animal electricity came from the muscle in the frog's pelvis; Volta, disagreed and insisted that it was a physical phenomenon. To prove it, Volta built the first battery, the voltaic pile, and it seemed as though he was correct. Galvani's health deteriorated, he lost his wife and then his funding dried up from his university, but Galvani and Volta were very respectful to each other during their disagreement. The same couldn't be said for the press and the public however, each side was vitriolic and scathing to the other. Volta had of course invented the first battery to which we all owe a huge debt, but Galvani didn't lose the argument as such. He had discovered bioelectricity and successfully demonstrated cell potential, that biological electricity has the same chemical underpinnings as the current between electrochemical cells and can therefore be reproduced outside of the body.

Conflicts of this kind happen all the time in science and it's not surprising that many reputations and careers have been ruined by such fractious debate, but perhaps it is worth remembering that history shows us time and time again that 'facts' can be such a fragile thing.

### Parity
In physics, parity relates to the symmetry of a system of particles. Until the mid-twentieth century, most physicists took it as a fundamental law of the universe that when any particle decayed, its parity stayed the same. This meant that matter was essentially symmetrical; the same particle could not possibly decay sometimes into two particles, and at other times into three particles, which in turn implied that it is impossible for matter to distinguish right from left or clockwise from anticlockwise. Physicists at that time believed that if the 'law of conservation of parity' were to be broken, the fundamental symmetry of matter would also be broken.

eblink 14 More information about hen Ning Yang and ung Dao Lee can be und here: tps://www. mmetrymagazine. g/article/ arch-2009/violating- rity

In summer 1956, physicists Chen Ning Yang and Tsung Dao Lee thought the unthinkable. What if parity really could be broken? They looked at the results coming out of particle accelerators involving weak nuclear forces, studied everything they could and carried out a large number of calculations to test the fundamental physical law that parity could not be broken. They worked out some possible experiments on paper to test their idea, then turned to a female colleague, scientist Chien-Shiung Wu, for her expertise in carrying out the experiment. Wu set up the hardware and devised the laboratory procedures for carrying out the experiment, and in 1957 Yang and Lee won the Nobel Prize in physics. Their calculations (and Wu's experiments) had established that parity is not conserved under weak nuclear interactions. They had proved the unthinkable; all matter was not symmetrical. At a deep level, this means that nature can tell the difference between left and right.

### Reverse thinking
In 1887, Albert Michelson and Edward Morley were determined to show that the speed of light varied according to a luminiferous ether that permeated all things. It was believed that light would travel faster in this 'ether wind', which resulted from the motion of the earth, than it would if traveling in the opposite direction. They designed a device that split a beam of light into two different directions and bounced it off mirrors until it eventually hit a target in the distance. They believed that the experiment would show that the beams would be slightly out of phase with each other, according to the direction and strength of the ether. They were disappointed to find that no matter which path the beam took, light always moved at precisely the same speed. Their experiment had taken years to complete, cost a fortune and only ended up proving the exact opposite. The speed of light is constant.

## How do artists use alternative viewpoints to make art?
If science has had its fractious debates and arguments over facts, then art has had a similar war over artistic style. In 19th century France, artistic taste was governed by the establishment, the Académie in Paris which deemed that close physical realism of historical subjects, portraits and religious themes was preferred to landscape and still life. Four young artists dared to disagree; Renoir, Sisley, Monet and Bazille. They began painting En plein air, or painting outdoors, not to gain a preliminary sketch for a future painting, but rather to capture the light of the landscape as it happened. It became known as Impressionism and it changed western art forever. Debates such as these rage on to this day; traditionalists who value skill and technique along with their creativity and abstract, contemporary artists who reject form for ideas and expression. I think there's enough room for both.

In some senses, all art is about seeing material forms from different perspectives. Mainstream art is usually concerned with style and substance; interpreting forms in a chosen medium in a particular style where physical likeness occurs to a greater or lesser degree. Abstract artists attempt to portray inner feelings, instincts, thoughts and the unconscious mind. Some artists try to look beyond what is obvious; they attempt to interpret the symbolic, metaphorical meanings underneath the surface of what is literally apparent, whilst others attempt to alter our perspective and change what we think we see or know about an object.

Perspective is an integral part of some art, but it is in itself a development by Renaissance artists and natural philosophers (early scientists) who developed ways to represent three dimensions onto a two dimensional surface. Perspective is something we consciously and unconsciously learn in western society. Some tribes-people from New Guinea for example, struggle to 'see' forms in two dimensions. When shown photographs of people at skewed angles performing tasks such as running or jumping they find it difficult to make them out. They have not developed the same visual culture to be able to see multiple viewpoint perspectives.

What is usual however, is that we most frequently view the world from a human perspective, that is from a raised elevation of around 1.4 to 1.8 metres when standing or 1.2 metres when sitting. Even though modern technology is enabling us to see the world from an interactive map or the top of tall buildings for example, most of how we view the world comes from these limited viewpoints. The challenge for the artist is to find new and interesting angles to re-examine what is already familiar.

## Cubism

Instead of depicting objects from a single viewpoint, the Cubists led by Georges Braque and Pablo Picasso tried to interpret the subject from multiple viewpoints within the same plane in an abstract form. Cubism was borne at the beginning of the twentieth century in a fast changing world. New technologies, sciences and mathematics were emerging as well as new psychologies and philosophical approaches that opened up the world to expanding visions and radically new perspectives. Impressionism and post-impressionism had greatly altered what art and specifically painting could look like. A genie was out of the bottle and, into the midst of all this innovation stepped the prodigious painter Pablo Picasso. When he unveiled his masterpiece *Les Demoiselles d'Avignon* in 1907 to much critical shock and ridicule, it was Braque who took up the baton and applied Picasso's lack of harmonious proportion, abstraction and distortion to his own interpretive artistic vision in *Large Nude 1908*. Both men were heavily influenced by Paul Cezanne, who said that everything in nature is based on the sphere, the cone and the cylinder, and who wanted to make the viewer of his paintings aware of the picture plane as well as the subject matter.

What Braque and Picasso did was to take this idea further into the psychology of how we see and understand objects, how our prior knowledge and relationship with it create impressions and feelings that in turn affect how we see it. For them, Cubism was an attempt to visualise these multiple relationships, and translate an object's appearance from multiple viewpoints at the same time. It was as though the flat surface of the painting was insufficient to convey everything they knew and understood about the subject matter.

## Paul Klee

Paul Klee (1879-1940) was a Swiss German visual artist, teacher and sometimes poet and philosopher who transgressed the boundaries of artistic style. His work was heavily influenced by his love of music (his parents were musicians) and his passion for poetry, which he saw as his ideal profession. He became friends with other notable artists of the time such as Kandinsky, Franz Marc and Auguste Macke and became part of the artistic group known as the Blue Rider. Conscripted into the German army in 1916 during the First World War, his artistic skills were utilised to paint camouflage on army vehicles, though he worked predominantly as a clerk to the treasurer, seeing little military action.

Weblink 15 Paul Klee's drawing entitled *Pinz anagoia (View of the Severely Threatened City of Pinz)* can be seen here: http://www. bridgemanimages. com/fr/ sset/148238/klee-paul-1879-1940/ iew-of-the-everely-hreatened-city-of-intz-1915-no-187-en-and-w-c-on-aper-on-cardboard

Nevertheless, the war did influence his art and he produced several pieces based on events that had been recorded by German Expressionist poets such as Wilhelm Klemm. Although Klee had not seen first hand the tragedy recorded by Klemm in poems such as Rethel in 1914, these poems heavily influenced his work at that time. In his drawing entitled *Pinz anagoia (View of the Severely Threatened City of Pinz)* Klee creates a fictional city and alludes to the allegories and metaphors of a war torn town. He uses multiple point perspectives of the town, combining bird's eye views with panoramic angles and also creates a fractured, shattered interpretation by incorporating Cubist techniques of angular geometry. Street signs become symbolic portents of doom; huge arrows in the sky, and architectural features are transformed into huge eyes that seem to penetrate the observer. Klee isn't giving us a literal interpretation of a war torn town as artists such as John Nash did, although he was easily capable and skilful enough to do so, what he gives us is an impression of the emotion of the event. Of

course, his lack of front line experience obviously influences what he has produced but nevertheless, where many war artists attempted to document the horrors of war literally, Klee attempts to connect with the feelings of trepidation and impending doom. When he draws Pinz he is trying to visually represent what he feels internally, through a jagged and fragmented lens.

## How do we learn to change our ways of thinking to develop the ability to see things from new and unique perspectives?

Human beings are creatures of habit. We fall into rituals quite easily, we organise our day around structured and ordered patterns; we tend to repeat ourselves over and over again. We tend to repeat ourselves over again. We like to think we are unique and of course we are in many ways, but in fact most of our behaviour is so predictable that a whole industry has grown up around it - advertising. The advent of the internet has seen social media and browser-based marketing develop to the point where they can almost tell you what you want before you know you need it. We only need to look at the culture of the world around us to see we are mostly victims of ever-changing consumer trends and fashions (even if we aren't fashion conscious).

Not only are we habitually restricted, but our interpretation of the world is limited too. Our conscious minds are heavily biased and our vision is based on only a fraction of the full light spectrum, using a binocular form of vision that is so restrictive we need our brains to fill in the gaps of what our eyes take in. We have only three cone receptors at the back of our eyes to see colour, many creatures have more, a shrimp has seventeen! This limited view of the world hampers our ability to invent, discover and innovate because such practice as this requires new insights and understandings beyond the obvious and literal. It is only when we are able to see things from new perspectives that we can solve problems more easily.

Exercises in perspective are familiar to most artists, as is the principle of viewpoints, whereby the artist envisages their subject matter from an unusual angle. Exercises such as this train the artists to 'see'. What that means in practice is that they not only spend hours in the intense study of forms and objects to inform their work, but also that they are taught how to look at the world from different visual and cognitive perspectives. Art students these days don't just learn how to improve their technique, as western artists did up until modern times, they are taught how to interpret, reinvent and even challenge what is happening in the world they live in. Some creative exercises seem quite strange at first because they destabilise your sense of comfort and familiarity with what you know. In time it is as though someone has taken blinkers from your eyes. Everything becomes much more vivid and clear and you begin to be able to not only visualise things from different perspectives, you begin to want to portray things in new and unique ways too.

At first, science may appear to be contrary to this. Science is evidential and knowledge based, it seeks surety and the confidence to make predictions, it tests, examines, investigates, inspects and records. It doesn't submit to the kind of wild, fanciful, elaborate concoctions that form the basis of art. But what is evident to me is that, to borrow an analogy, science is a game of two halves. The second half may be about consolidating, experimenting and evidence gathering, but the first half is pure speculation.

Innovation can't happen without informed speculation, without formulating ideas and concepts or trying to break the boundaries of what is known or possible. This requires creativity and is the artist's playground, but (in my opinion) it should be taught to scientists too, because how else will you discover anything new? The only difference between artist and scientist is that the artist expands upon the abstract whereas the scientist seeks to rationalise it. The important thing to understand is that you have to know where to look for it in the first place. What would you rather have in the preliminary stage? A few, limited, narrow ideas or a plethora of wild, fanciful, unfeasible ones? I hope you'd answer neither, that you'd want well thought out, rational hypotheses and that's where these creative exercises come in.

## Drawing from alternate viewpoints
(Please see the appendix for resources to accompany these exercises)

**Figure 23** *Hairdryer and curling tongs* by Paul Carney

Familiar objects can be transformed with a change of perspective and lighting.

In this exercise you will be translating information from the viewpoint provided to a new perspective. This tests your powers of visualisation, as well as your ability to calculate how the details will look from a different angle.

1. Study the picture of the Buddha ornament. You could use any object for this exercise, preferably one you can pick up and examine from different angles.

**Figure 24** Visualization drawing

2. Draw the image on tracing paper, as though it were a giant statue and you were a tiny human being standing before it.

3. Now draw the Buddha on a different piece of tracing paper as though you were a bird flying above its head.

4. Now imagine you are a fly resting on its shoulder. Look up towards its head. What would you see? Draw it again on a separate piece of tracing paper.

5. You now have several drawings of the object from different perspectives. Lay the tracing paper drawings on a new sheet of white cartridge paper. Arrange them as carefully as you can, playing with compositional elements, think about the dynamics between the shapes, flip the drawings, rotate them, even cut them up if you wish, until you produce a new, multiple -perspective drawing of the object.

6. But you haven't quite finished yet! If you can, photocopy the new composition. Now think about the texture of the object and apply some drawing of this in key places in your work. Add hand-drawn lettering, perhaps words that describe your feelings about the object or some random thoughts. Finally, add some tonal shading, creating dark and light contrasts to produce your own work of art.

## Surreal viewpoints

For this exercise you must create a drawing from three words selected at random from the lists provided. You might add extra words to the list yourself. It would be a good idea to cut the words out and place them in separate bags so you can make a blind choice.

Task: Draw an image of an **adjective noun** from the perspective of a **viewpoint**.

|    | Adjectives | Nouns | Viewpoints |
|----|------------|-------|------------|
| 1  | Surreal    | Ice Cream | Slug |
| 2  | Magical    | Dog   | Tyrannosaurus Rex |
| 3  | Monstrous  | Chair | Soaring Eagle |
| 4  | Acrobatic  | Sandwich | X-Ray |
| 5  | Soporific  | Hairbrush | Telescope |
| 6  | Excitable  | Key   | Microscope |
| 7  | Glamorous  | Teapot | Sound Wave |
| 8  | Brave      | Clock | Bacteria |
| 9  | Aggressive | Pizza | Quantum Particle |
| 10 | Creepy     | Shirt | Cloud |

**Further alternative viewpoints exercises:** next time you're out walking, try looking at things from different angles and perspectives. Try looking up at the tops of buildings or see things from a low perspective. You'd be amazed at how much more you notice. Too often, we see everything from our human level and we miss so much. Mind, you have to be careful that you don't bump into things! Also, try drawing things from the perspective of a cat or dog, a bird's eye view, or even a spider's view from the corner of the room. Take photos from these angles too, then practice drawing from the photos.

RALIT & RORER
TRALI & ERRRO
TRIAL & ERROR

## 9. TRIAL & ERROR

'The process of finding a solution to a problem by trying many possible solutions and learning from mistakes until a way is found.' (Wiktionary, 2018)

### How do scientists use trial and error to innovate?

'If you want to have good ideas you must have many ideas. Most of them will be wrong, and what you have to learn is which ones to throw away.'

Linus Pauling (Crick, 1995)

'An expert is a person who has made all the mistakes that can be made in a very narrow field'.

Niels Bohr, as quoted by Edward Teller (Coughlan, 1954: 62)

### Mutual induction

Michael Faraday (born 1791) was a self-taught scientist, who learned science by reading books and watching lectures. He had a determined nature and was devoted to discovery through experimentation. He was famous for never giving up on ideas; if he thought an idea was a good one, he would keep experimenting through multiple failures until he got what he expected, or until he finally decided that his intuition was wrong. He spent over ten years investigating and experimenting with the phenomena of electromagnetism until his breakthrough came when he wrapped two insulated coils of wire around an iron ring, and found that upon passing a current through one coil a momentary current was induced in the other coil. This is now known as mutual induction.

**Weblink 16**
Thomas Edison's light bulb drawings (1886) can be seen here: https://upload. wikimedia. org/wikipedia/ commons/b/ b2/Edison_ Lightbulb_ Drawings_2_ Mus%C3%A9e_ des_Lettres_et_ Manuscrits.jpg

### The first practical incandescent light bulb

Thomas Edison and his team of researchers in Edison's laboratory in Menlo Park, New Jersey, tested more than 3,000 designs for light bulbs between 1878 and 1880. Edison tested more than 6,000 plants to determine which material would burn the longest. In November 1879, Edison filed a patent for an electric lamp. The patent listed several materials that might be used for the filament, including cotton, linen and wood. Several months after the 1879 patent was granted, Edison and his team discovered that a carbonised bamboo filament could burn for more than 1,200 hours. Bamboo was used for the filaments in Edison's bulbs until it began to be replaced by longer-lasting materials in the early 1900s.

## How do artists use trial and error to make art?

Trial and error takes place in the process of making art and can take many forms according to the type of art being created. Performance artists may use movement, speech and sound whereas a painter might use brush, paint and canvas. For sculptors it is the formation and synthesis of cutting, shaping and forming materials by adding and/or subtracting materials. Textile artists and craftspeople use different materials but similar processes of gathering, combining, altering and manipulating materials. In all events, the processes used depend on the artist's ability to make evaluative judgments about how best to proceed, to take action then either correct or modify the outcome of that action, or move on to the next one. This is evident in ceramic art when a potter is throwing clay on a wheel for example. The potter is making split second decisions about form, thickness, shape and direction and, usually working to a pre-determined plan, the clay and the process itself helps define the eventual outcome. In pottery, trial and error is very much inherent to creation.

Also useful to consider is how artists constantly revisit the same theme. Think of Henry Moore's recumbent figures, Monet's haystacks, or Dali's numerous clocks and long legged elephants. Presumably the artist isn't satisfied with one interpretation of the subject; there is a need to keep exploring the theme, to depict it in different ways and at different times. Of course, there is the familiarity of repetition combined with the general limits of our own cognition that are factors in this process, not to mention the exploitation of commercially successful forms. But in general, the artist is involved in an internal struggle to examine the subject matter in greater depth, to acquire further understanding and to reach a point where they feel they have exhausted the object of curiosity. This artistic process is an internal struggle to meet a personal objective. It isn't a struggle to solve a problem, invent something or identify a cause as is required in science, but nevertheless, the process is similar. We create something, we critically analyse it, and then we attempt to refine what we have made in light of critical opinion. (Artists know this as evaluation).

All young people learn to do this in their science lessons too as part of the scientific process, but I feel that drawing can offer something unique that is not learned in the laboratory. That is because drawing is essentially a process of moving from one mistake to another. It is constant, cognitive correction, an ongoing cycle of trial and error that forces the artist to make immediate decisions and choices, usually within very short time frames. In the scientific process, this evaluative decision-making is often much longer and comes at set periods and points. Information is usually gathered first and this can be an enormous process. Only then will it be subjected to evaluation and scrutiny and even then, interpretations of what the data means can differ greatly. So someone who is skilful in drawing techniques may well add something of value to the scientific process, not least of all because drawing helps us deal with mistakes and failure. If you can deal with constant, creative frustration then you learn to see that failure is all just part of the bigger picture and nothing to become overly anxious about.

## Egon Schiele

**Weblink 17**
More information about Egon Schiele and examples of his work can be found here: http://www.artnet.com/artists/egon-schiele/

Austrian artist and student of Gustav Klimt, Egon Schiele was a controversial figure who died young at the age of 28 from Spanish flu. Whilst he produced many landscape paintings, the main obsession of Schiele's art was the human form. He was an avid painter of portraits and produced many self-portraits in various poses and expressions, some of them naked. He has become more known for his provocative life studies of people, some quite sexual, but often rather grotesque and alarming. He rarely painted

figures in recumbent, static poses typified by the earlier periods; instead his poses were lively caricatures in animated positions. Also typical of his work are flowing, organic outlines and unfinished angular brush strokes.

What is apparent from looking at Schiele's catalogue is the consistency of subject matter, the ongoing need to constantly reinterpret familiar subjects again and again. He knows and understands the human form both intimately and through paint, but this is not enough. He isn't satisfied with merely knowing his subject; he wants to tell stories through his depictions, to evoke feelings and desires, even to provoke us into disgust. He died three days after his wife (she was pregnant with their child) in 1918 and during that time he drew several sketches of his wife that I think are poignant. There is an unmistakeable trace of faltering sickness in the drawing certainly, but what I think is more beautiful is the way in which gestural fluid lines evoke powerful emotion. The drawings are crude, technically full of mistakes, but in his final moments they aren't important anymore, and what we are left with is the beauty of the final line.

### How might learning how an artist employs the characteristics of trial and error help a scientist innovate?

The process of innovation is like navigating in a sea of fog with the wind against you. Just occasionally there is an opening in the clouds and the sun shines momentarily. Most scientists never get that opening in the clouds and discover anything significant or outstanding, but it seems to me that the scientific struggle to discover is similar to the artist's struggle to create; it is an inherent part of the practice. Just as the artist refines, adjusts, alters and modifies their colour, line or shape on the canvas or paper, so the scientist uses the scientific method to hypothesise, analyse the results of their experiments, form conclusions from them and decide how best to proceed.

Just as the scientist pores over the data and the results of the experiment, so the artist pores over the artwork; both are reflecting, making inferences and deducing, in an attempt to reach an ultimate goal. The difference is that the scientist's goal is evidential, whereas the artist's is a self-defined conclusion. For both however there is a constant and ongoing process of: action, evaluation, modification and further action. The artist's cycle of creation is usually more immediate and intuitive than the scientific method, where the gap between the gathering of information (action), evaluation and further modification is usually greater. For both however, this evaluative, reflective, trial and error process is dependent on making accurate observational inferences from the information gathered or recorded, and having the patience and fortitude to continue, even when there is a continued process of failure.

Of course, a scientist will learn this process through their own experimentation and in the course of their studies, so why would they need to learn to draw? What can they possibly get from drawing that they can't learn from practical science?

Well, in addition to learning the important attribute of seeing with more intensity and clarity mentioned earlier, I believe drawing helps us to understand the creative process, which is largely a system of trial and error; taking an action, evaluating it, and either correcting the action or taking further action. If we become familiar with this process we become more confident and assured that this cycle will inevitably yield results. Learning to draw also brings us into contact with self-doubt (a powerful agent of failure) and if we can learn to deal with that we will surely become more confident in other fields.

## Drawing exercises to understand the trial and error process
(Please see the appendix for resources to accompany these exercises)

**Figure 25** *Daffodil* by Paul Carney

This drawing was produced in one day from direct observations, making marks, evaluating them, then modifying them or moving on.

All drawing is a process of trial and error. We make marks then we evaluate them to judge their accuracy. If we're happy we move on, if not we correct the marks then carry on (or give up!). But this exercise asks you to look closely, remember what you see and then draw from memory. This cycle is repeated so that the more you do it, the better your short-term visual memory becomes.

For this exercise you'll need some subject matter or a photograph to work from. Houseplants are good, or try using something with which the person is very familiar. I've done this in art rooms by asking people to draw the front door of their house from memory. It is incredibly difficult to do, despite the fact that we see them everyday, because our brains tend to partition irrelevant information such as this out of the reach of immediate recall. (Try it yourself!) I ask them to take the drawing home and compare it to the actual door, then make corrections to the original drawing.

This exercise is a variation on that. It is best done with charcoal, a graphite stick or a soft 6B pencil on rough paper, though you might use various coloured pens for each drawing stage so you can compare the differences. Try to only draw from your memory;

things you have actually seen. There is a temptation to draw from your symbolic mind and what you think the object should look like, rather than drawing what you have actually seen.

1. Look at the object you have selected (no drawing during this stage) or study the photograph for ONE minute.

2. Remove the photo or the object and draw it from memory.

3. Look at the image or object again for one minute, but this time study the details you may have missed the first time. Look for more detail, internal textures, shadows, patterns and reflections.

4. Revise and improve the drawing from memory, without seeing the image or object.

5. Repeat this stage until you have corrected the drawing three times.

**Figure 26**
Drawing moves short term working memory to long term storage and improves our ability to recall it.

**Further trial and error drawing exercises:** constant practice of observational drawing is a great way to develop these skills. It really doesn't matter how 'good' or 'bad' you think your drawings are, all that matters is that you are engaging in the act of making decisions, recording information, evaluating it, then modifying it if necessary. In essence, this is what both the scientific method and the creative cycle are!

# VISUALISATION

## 10. VISUALISATION

'The act of visualizing, or something visualized.'

(Wiktionary, 2018)

Representing information in visual forms is one of the primary purposes of drawing. Humanity has invented all manner of codes, symbols and conventions to represent information. Arrows indicate direction, emojis convey mood and feeling and road signs instruct us on how to drive safely. These symbolic codes and conventions are made and invented by us, they have evolved, so that everyone who understands the symbol can perform the same function. Drawing for information is traditionally focussed on making the complex more explicit. We use diagrams to show an object's structure or construction, or make clear a set of operations or procedures for example. We use charts and graphs to illustrate patterns or behaviours or diagrams to explain concepts and ideas. These are ways in which virtually all of us use drawing and they don't depend on us being particularly skilful to do so.

Mathematicians use drawing to construct symbolic representations of processes, sequences, operations and calculations. Their rough calculations on paper, whiteboard or chalkboard, can be, in my artist's eyes, as valid a form of artistic expression as mine, and whilst the aesthetic is largely insignificant to the mathematician, the end results are as valid an art form as a visual artist's work. After all, if an unmade bed can be art then why not complex, elegant equations?

As a layperson, when I'm studying mathematical equations I don't understand the codes that are used to explain the concept. They are beyond my comprehension. But I can see the bigger picture of exploring thoughts, ideas and concepts, pushing the boundaries, failing, reaching dead ends then picking up new lines of thought because I do this when I am drawing, albeit in a different intellectual context. But by emulating this process though drawing we can demonstrate how these complex actions operate. By challenging students to try to visualise highly complex sequences using limited modes of expression we begin to help them become familiar with the struggle of defining that which is outside of their usual thinking.

## Visualisation in science

Even notable physicists and mathematicians such as Shin-Tung Yao (2012) who proved the Calabi conjecture on string theory finds pictures helpful when grappling with difficult concepts. In fact, his work deals explicitly with geometry because of its close relationship to nature and the type of questions he struggles with.

Professor John K. Gilbert (2005) of the University of Reading who has published much research on the importance of visualisation in science, believes that visualisation is a major strategy in all thought and must therefore play a major role in science education.

American scientist Barbara McClintock (Fox Freeman, 1984),who won the Nobel Prize in 1983, described her success in genetics as 'feeling for the organism'. She said that she familiarised herself so well with plants that she could imagine herself 'down among the genes.'

Nobel Prize-winning molecular biologist Joshua Lederburg claimed 'I literally had to be able to think ... "What would it be like if I were one of the chemical pieces of a bacterial chromosome"? And try to understand what my environment was, try to know where I was, try to know when I was supposed to function in a certain way, and so forth.' (Donahoe Martin, 2003: 168).

Nikola Tesla (1919: 4) inventor, electrical engineer, mechanical engineer and physicist said:

> 'When I get an idea I start at once building it up in my imagination. I change the construction, make improvements and operate the device in my mind. It is absolutely immaterial to me whether I run my turbine in thought or test it in my shop. I even note if it is out of balance. There is no difference whatever, the results are the same.'

When asked how he was able to think of the Theory of Relativity, Albert Einstein said:

> '... the words or the language, as they are written or spoken, do not seem to play any role in my mechanism of thought. The psychical entities which seem to serve as elements in thought are certain signs and more or less clear images which can be "voluntarily" reproduced and combined.' There is, of course, a certain connection between those elements and relevant logical concepts. It is also clear that the desire to arrive finally at logically connected concepts is the emotional basis of this rather vague play with the above-mentioned elements. . . . The above-mentioned elements are, in my case, of visual and some muscular type. Conventional words or other signs have to be sought for laboriously only in a secondary stage, when the mentioned associative play is sufficiently established and can be reproduced at will.
>
> (Answer to a survey written by the French mathematician Hadamard, 1945)

Visualisation in mathematics isn't only about providing diagrams, charts and tables as an aid to illustrate information. Visualisation has an important role to play in problem solving, to identify the key components of the problem, via internal models and external representations. So visualising in mathematics helps us to understand the problem, but it is also used to model situations and to plan ahead. We need to

practise how to internally visualise information, represent ideas, compare multiple representations, make connections and share our ideas with others.

Lastly, Feynman diagrams are some of the most important visualisations ever made. Invented by American physicist Richard Feynman in 1948, they are pictorial representations that describe the behaviour of subatomic particles. They give simple visualisations of very complex, abstract mathematical formulas and have revolutionised nearly every aspect of theoretical physics.

## Visualisation in art

When interviewed by André Parinaud in1973 about the thought processes behind his art, renowned painter, sculptor and visionary Salvador Dali (Parinaud, 1973) explained he was able to project himself inside his own mental cinema. Presumably, he constructed images on his imaginary screen and played out the resulting ideas in order to refine his thoughts. And just like the Prehistoric hominids thousands of years before him, Henry Moore picked up a pebble from a beach one day in 1952 and recognised a human form in it (Hedgecoe, 1986). He took it back to his studio and created his now famous work *Arnhem Warrior*. But perhaps it is Leonardo da Vinci 1452-1519 who best illustrates the power of imagination in his work. He said:

> 'Look into the stains of walls or ashes of a fire, or clouds, or mud or like places, in which, if you consider them well you may find really marvelous ideas.'
>
> (Wray, 2005: 90)

In fact, it is reported that he regularly took his students out on the streets of Italy to stare at faded crumbling walls and plaster facades to illustrate his point.

## Can we learn to visualise?

Visualisation is a significant area of STEM education. In addition to external visualisations such as diagrams, graphs, charts and computer simulations, internal mental models play a key role in learning. Visualisations help learners to engage with the subject and to interact with the content, making information more legible than mere text alone. However, internal visualisations, where models are constructed and represented in the mind are of the greatest significance in STEM education. This mental capacity must be taught. It doesn't occur naturally in most people without being nurtured and it is here where art education can play a role. So what is visualisation and how can we teach it more effectively through art, especially drawing?

It sounds easy enough. We can all do it, you just close your eyes and think of something. That's visualising isn't it? We do it every night when we dream. So yes, we all visualise to greater or lesser degree, but some can do it more effectively than others. A good analogy for this is to go DIY shopping with your partner and ask them if they can imagine how a certain wallpaper would look in your living room. Many people do this quite easily whereas others struggle, they need to take a sample home and try it in situ.

Artists build their imaginative powers through constant practice. They use them in a variety of ways; to visualise which colour will work best in their composition for example, and though they might also physically test other colours, in time they develop an ability to know instinctively what will work and what won't. Of course

artists stretch their imaginative powers in other ways too, to imagine concepts and solve design problems, though it is just as true for artists as it is for anyone else that the more you practice these skills the better they get, and many artists fall into bad habits of narrow, closed thinking.

Scientists (and mathematicians and engineers) need visualisation skills too and this comes about in different ways and at different stages of their work. At the hypothesis stage of an idea they may need to conceptualise their proposal, and consider which processes, materials and substances will most likely work and which won't. Their pre-existing knowledge of these factors will help them form decisions in their mind of how best to proceed, but the synthesis of this knowledge with the ability to visualise the likely sequences of events that will occur from the operation is crucial. In addition, visualisation is a constant tool in the scientist's mind that brings clarity to the uncertain, helps solve problems, enables them to see ahead and foretell future events. With this in mind, it makes sense therefore for visualisation skills to be learned and practiced in STEM subjects as well as in art.

**Figure 27**
*Champagne Bottle*
by Paul Carney

The exploding bottle has been developed into a highly imaginative composition representing different moods and emotions.

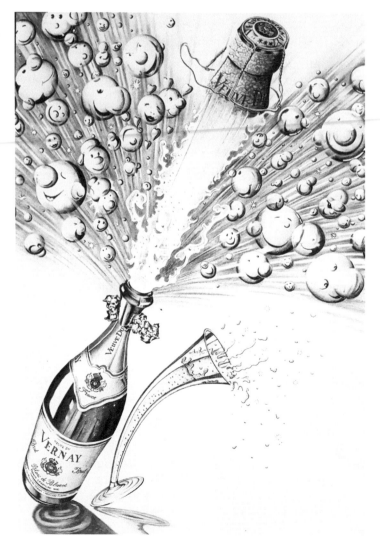

74

## Visualisation drawing exercises
(Please see the appendix for resources to accompany these exercises)

### Onomatopoeia
Onomatopoeia is a word that mimics the sound that it names. Onomatopoeia in nature would be words imitating sounds in nature. For this exercise I want you to draw what you imagine might make these strange sounds. The only rule about this exercise is that you are NOT allowed to copy anything directly from the known world. For example; you can't simply draw a known animal for any of the words, but you can base a new original composition based on features of flora and fauna (or objects) that you know of. You ARE allowed to adapt, alter and change aspects of things you know and are familiar with into something new, but your work must be an entirely original composition.

Read the words carefully in your head until you feel comfortable with them. Follow the instructions alongside the word to find out how they should sound. Then simply sketch out what you think might make that sound. Remember, it doesn't have to be a creature. Lots of things make sounds; something falling, vibration of something in the air or water, movement of some kind, musical instruments, or all the various sounds the weather makes.

Lastly, try to imagine what kind of thing would make this sound? Is it a tiny object moving slowly through rough terrain? Is it something whooshing through the air? An attacking roar or a defensive cry? Is it being made underwater? In another atmosphere or strange environment? The only limit is your imagination.

1. A high-pitched sound with a moderate tempo: KRRNGEH KRRNGEH RAK RAK WRRRRRR

2. A shrill, frantic sound with a fast tempo: ZF-I ZF-I ZF-I ZF-I ZZF ZF

3. A deep, bassy sound made with slow, monotonous rasp: AVOOOOOO WAAAAAH. MIY-AN-QUAAAAAAA

4. A garbled mid-pitch noise produced at medium tempo: GGGGHAR-RA-KOOOO

5. Low pitched and fast: CHWOB WOB WOB. CHWOB WOB WOB

6. Sprawling, reedy cry: OOOOOOOOOOOOO YANK-OOOOOOO

7. A quick, mid-pitched rattle: KWAN TEE YAA KNEE.

8. Ponderous, deliberate vibration: SSSSSHHHAAAA - U. ASSSSSSHHHHAAAA - U

9. Screeching, quick paced and alarming: HYIKA CHYIKA CAKKKA KA KA KA KAAAAA

10. Languished, plodding beat: TRP TRRP TRP TRRRP TRRRRRRRRP.

## Visualising information

The purpose of this exercise is to try to interpret complex, sophisticated information using known and invented marks, lines and symbols. There is a video provided for reference in this exercise or you can simply use yourself, the teacher or willing volunteer to pose. Thinking creatively here, you might be able to employ a dancer, dramatist, athlete or martial arts person to pose for the subjects to make it more interesting.

You are challenged to represent the movement of a subject using drawing media. You must only represent the movement itself, not get bogged down in drawing the details of the subject matter. You might work as groups or collaborate your results afterwards to share methods.

Watch the first 40 seconds of the Swan Lake video showing the fabulous Uliana Lopatkina dancing the dying swan at the Tenth International Ballet Festival Mariinsky. (You can do a simple search for this in Youtube e.g. https://www.youtube.com/watch?v=-T2UeKKac-s)

**Task:** Using drawing, how many different ways can you find to represent the movement of the dancer?

Consider:
- the skeletal and muscular locomotion, as a whole and as individual parts;
- the movement of the whole figure around the space;
- the different sequences or stages performed in the dance and how they relate to the whole;
- expression and emotion.

If you are able, collaborate your results with others and evaluate the results.

Are you interested in the physics and mathematics of the movement, aesthetics, the artistry of human expression or the dance sequences? Or all of these?

Who has illustrated the flow of the movement of arms, legs, feet and hands etc. successfully?

Would another dancer (who did not know this piece) be able to perform this dance using your drawings?

What aspects of the dance are extremely difficult to define through drawing? (The fine expression of the emotions of the piece, the precision of the movement and the technical mastery of the medium.)

**More visualising drawing exercises:** draw from your imagination constantly. Try to draw impossible things or places where you've never been. If you're going on holiday, try to draw what you imagine it will look like when you're there. Draw what you hope you might get for Christmas, invent your own creatures, cars or vehicles, or design characters for stories you have invented. And don't forget to visualise things in the textures and patterns you see on your travels!

## Olaf's mad mechanical machines

King Olaf is a rather demanding King who doesn't take no for an answer. If he wants something he gets it and he has a team of devoted scientists, mathematicians, engineers and inventors to build anything he wants. Use the resource sheet in the appendix to invent:

### 1. A cloud catching machine

Invent a cloud catcher to catch all the clouds blocking the sunlight from king Olafs sun bed, squeeze the rain from them, use it to water the plants, then put the empty clouds somewhere else. You'll need to think of:
- How the machine will reach that high
- Stability
- How you will catch the clouds
- How you will drain water from them
- How you will move the clouds away from the King's sun bed

### 2. A tree topiary cutting machine

King Olaf wants all the trees in his kingdom to be cut into funny animal shapes. Invent a machine that could do this. You'll need to consider:
- How to get your machine to any tree in the kingdom. How it will reach up to high and low branches
- How it will move in complex ways to create the shapes. How you will cut big branches safely
- How you will remove the unwanted debris

### 3. A sheep hair-straightening machine.

The king hates curly hair. Invent a machine to straighten all the sheep in the kingdom's coats. You will need to consider:
- How to catch the sheep
- How to hold them in place safely
- How to move your machine around the sheep

### 4. A bird-painting machine.

The king is dismayed that the birds in his lands are such boring colours. Invent a machine to paint the bird's different colours and patterns. You will need to consider:
- How to catch the birds safely
- How to hold them in place so as not to hurt them
- How to make different shapes and patterns on the birds

### 5. A mountain-moving machine.

The king has a few mountains in his kingdom that he thinks are blocking his view of the sunset. He wants a machine inventing that can move them out of the way a few hundred miles or so. You'll need to consider:
- How you are going to cut into solid rock
- How you will move large quantities of earth and rock

**Rules:** No drones, or computers. The king likes levers, pulleys, gears, and mechanical machines.
**You must only use the items on the list plus up to 3 items of your own choice.**

## 11. SUMMARY

I believe that these exercises can and will make a difference to the work of both artists and scientists alike. That's not because they have been cleverly designed, it is because drawing is so profoundly good at teaching us how to interact with the world around us. It is enormously diverse, so inherent to human nature and so instinctive. We lose the passion for drawing at a young age when we become too absorbed in making things look realistic or when we compare what we have done with others. Our frustrations lead us to believe that we can't draw, when in fact we all draw every time we write our name.

It is very important to bear in mind that there's little point doing these exercises once and then forgetting about them. That is like lifting a few weights once and expecting to develop big muscles! Constant practice and repetition is everything and that requires you to enjoy drawing! I can't stress enough that it really doesn't matter how good the outcomes of your artistic endeavours are. You might think you are simply hopeless at drawing, but I can assure you that this doesn't matter one bit. All that matters is that you enjoy the process of doing it and that you learn something along the way. You'll probably start out lacking in confidence, but one day you'll forget you were even anxious at all and realise that drawing is just part of your everyday experience.

*Paul Carney*
August 2018

# REFERENCES

Aichele K Porter, (2006) 'Paul Klee, Poet/Painter', *Studies in German Literature Linguistics and Culture*, Camden House, Suffolk

Arp, Hans (1966) *Jours e euillés: Poèmes, essaies, souvenirs*, Gallimard, Paris

Ayrton, Michael (1957) 'The Act of Drawing', in *Golden Sections*, Methuen & Co, London, UK

Bobex, Eliza and Barbara Tversky, (2009) *Creating Visual Explanations Improves Learning*, University of Massachusetts and Stanford University, New York, USA

Borland, Christine, (2002) *The Contemporary Arts Museum (*Press Release), Houston, Texas

Boyer, Paul (1981) *An Autobiographical Sketch Related to My Efforts to Understand Oxidative Phosphorylatio*n, John Wiley & Sons Ltd, London

Burnell J B (1977) 'After Dinner Speech', *Annals of the New York Academy of Science*, 32(1), December

Coffield, Frank (2013) *Learning Styles, it's time to move on*, National College of School Leadership, Ref: PB1046/LEVEL2/LPD/OP/COFFIELD, National College for School Leadership, Department for Education, Nottingham

Conway,William Martin (1889) *Literary Remains of Albrecht Durer,* Cambridge University Press, UK

Copeland, S (2017) *Synthese*, Springer, Netherlands

Coughlan, Robert (1954) 'Dr. Edward Teller's Magnificent Obsession', *Life*, 6 September

Crick, Francis (1995) in his presentation *The Impact of Linus Pauling on Molecular Biology*, The Salk Institute for Biological Studies, California, USA

Donahoe, Martin (2003) 'Advice for Young Investigators', *Historical Perspectives on Scientific Research*, Kluwer Academic Publishers, Dordrecht, The Netherlands

Einstein, Albert (1945) Answer to a survey written by the French mathematician Jaques Hadamard, from Hadamard's 'An Essay on the Psychology of Invention in the Mathematical Field'

Ernst R R (1991) *Nobel Prize Biography*, https://www.nobelprize.org/prizes/chemistry/1991/ernst/auto-biography/

Ervynck, G. (1991) 'Mathematical creativity'. In D. Tall, *Advanced mathematical thinking*, Kluwer Academic Publishers New York, 42-52

Fox Keller, Evelyn (1984) *A Feeling for the Organism: The Life and Work of Barbara McClintock ,* W H Freeman

Gilbert, John K. (Ed.) (2005) *Visualization in Science Education*, Springer, The Netherlands

Goel, Vinod (1995) *Sketches of Thought*, MIT Press, London

Hadamard, Jacques S (1945) *A Mathematician's Mind, Testimonial for An Essay on the Psychology of Invention in the Mathematical Field*, Princeton University Press

Harris, Henry (1998) *Howard Florey and the development of penicillin*, lecture given on 29 September 1998, at the Florey Centenary, Sir William Dunn School of Pathology, Oxford University (sound recording)

Hedgecoe, John (1986) *Henry Moore,* Ebury Press, Tinturn, England

Higgins, Dick (1979) 'A Child's History of Fluxus', *Lightwork's Magazine*, No. 11/12, Birmingham, USA

Judson, Horace Freehand (1980) *The Search for Solutions*, Holt Rinehart and Winston, New York, USA

Knowles, Alison (1965) *Nivea Cream*, performed on 25th November 1962 at Alle Scenen Theatre, Copenhagen at a Fluxus Festival

LIGO Caltech, (2017) Press Release 16 October, https://www.ligo.caltech.edu/page/press-release-gw170817

National Human Genome Research Institute, Bethesda, Maryland, USA, https://www.genome.gov/10001772/all-about-the--human-genome-project-hgp/

Parinaud, André (1973) *Comment on deviant Dali, les aveux inavouables de Salvador Dali*, R. Laffont, Collection Vécu series, Paris, France

Pasteur, Louis (1854) *Lecture at the University of Lille*, 7 December

Pauling, Linus (1958) 'Molecular Disease', *Pfizer Spectrum magazine*, USA, 6,(9), 1May

Poincaré, Henri (1914) *The Foundations of Science: Science and Hypothesis, the Value of Science, Science and Method, the Science Press*, New York, USA

Rewald, John (1962) *Post-Impressionism, From Van Gogh to Gauguin*, Museum of Modern Art, New York, USA

Temple Bell, Eric (1986) *Henri Poincaré: Men of Mathematics,* Simon & Schuster

Teller, Edward, Wendy Teller and Talley Wilson (1991) *Conversations on the Dark Secrets of Physics*, Basic Books, New York, USA

Tesla, Nikola (1919) Chapter 1 'My Inventions and Other Writings', *Electrical Experimenter Magazine*, USA,

Tesla Nikola (1931) in 'Tesla Says Edison Was an Empiricist', *The New York Times*, 19 Oct

Tversky B and Suwa M (2005) *Thinking with Sketches*, Oxford University Press, UK

Yao, Shin-Tung (2012) *The Shape of Inner Space String Theory and the Geometry of the Universe's Hidden Dimensions*, Basic Books, New York, USA

Wilkins, Maurice (2005) *The Third Man of the Double Helix*, Oxford University Press, London

Wray, William (2005) *Leonardo Da Vinci in his own words*, Gramercy Books, Random House, London.

# APPENDIX

## Observation Drawing Resources
1 and 2. Doppleganger Drawing

**Observation Drawing Resources**
5 and 6. Upside Down Drawing

# Adaptation Drawing Resources
## 7, 8, 9 and 10. Object Adaptation / Improvisation

# Collaborative Drawing Resources
## 11a and11b. Group Drawing

# Collaborative Drawing Resources
## 12 and 13. Peg Drawing Exercise

# Knowledge Drawing Resources
## 14. House Drawing

# Knowledge Drawing Resources
## 15 a, b, c, d. House Drawing further information

**Knowledge Drawing Resources**
16. View of the back of the house

## Knowledge Drawing Resources
## 17. Draw what's in the box

Artificial Flower (Basic)

1. It's a beautiful thing.
2. It is colourful.
3. Usually, they grow in your garden.
4. It is made from silk and plastic.
   Answer: artificial flower.

Cat ornament (Basic)

1. There are lots of different types of these.
2. It is an animal.
3. It has whiskers.
4. It is made from wood.

Dog ornament (harder)

1. This is cute.
2. It has ears.
3. It has four legs.
4. It is made from ceramic.

Bird planter (harder)

1. This is small.
2. It is brightly coloured.
3. It is resting on a barrel.
4. It is used to grow organic material.

Elephant ornament (hardest, including misleading information)

1. These are frightening.
2. They're usually too big to fit in the box.
3. This is brown with patterns on it.
4. Some people don't like them.

# Methodical Drawing
## 18a and b. Raisin Drawing Worksheet

In this exercise, the students must draw a series of small, similar looking objects (but not identical) in the manner of recording and cataloguing them. I've chosen raisins in my example but other objects could be selected such as popcorn. Anything that is similar, but unique in appearance will do.

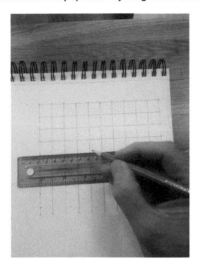

Draw a grid large enough to accommodate the items you are drawing. Here I decided on a 10mm grid to fit the size of my raisins.

Draw the raisins using a black fineliner pen. Notice the unique characteristics that make up the form of the raisin.

Focus and concentrate hard to keep filling the grid with your drawings. Remember, you must draw a different raisin each time!

I've only drawn eighty items here that took me a couple of hours. Could you draw eight hundred? How about eight thousand?

Would you be able to identify each raisin you have drawn? Why is this so difficult?

How might you improve the exercise so that later identification of the objects could be made?

**Viewpoints Drawing Resources**
19. Buddha Resource Image

# Trial and Error Drawing Resources
## 20. Car Image

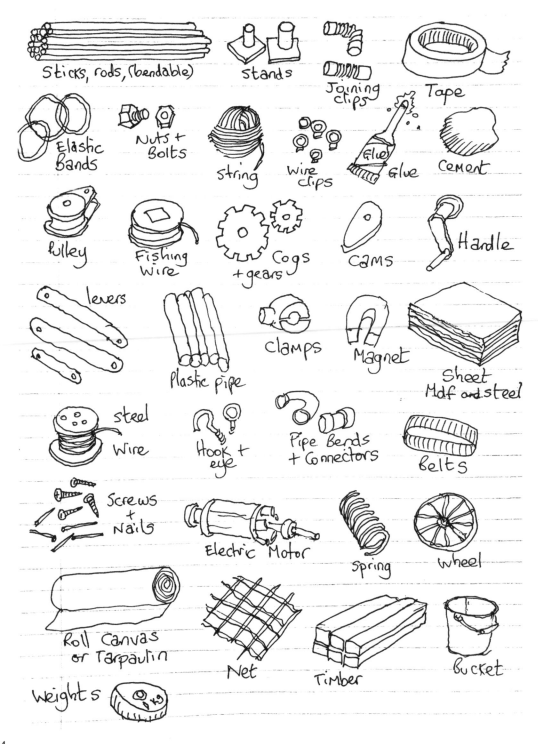

Sticks, rods, (bendable)

stands

Joining clips

Tape

Elastic Bands

Nuts + Bolts

string

Wire clips

Glue

Cement

pulley

Fishing Wire

Cogs + gears

Cams

Handle

levers

Plastic pipe

clamps

Magnet

Sheet Mdf and steel

steel Wire

Hook + eye

Pipe Bends + Connectors

Belts

Screws + Nails

Electric Motor

spring

wheel

Roll Canvas or Tarpaulin

Net

Timber

Bucket

Weights

## AUTHOR PROFILE

Paul Carney is a nationally recognised, National Society for Education in Art and Design (NSEAD) registered, art consultant having delivered specialist art Continuing Professional Development in schools, colleges, galleries and universities across the UK and for the UK's leading training providers. Paul specialises in teaching drawing and painting and is a practicing professional artist and designer. He is a Council member for the NSEAD, which means he is involved in national art education issues.

Paul lives in Newcastle upon Tyne where he runs his highly successful art website: paulcarneyarts.com which provides high quality teaching resources and advice to teachers around the world. He has over twenty years teaching experience at Primary, Secondary and Post-16 levels of education, is an Advanced Skills Teacher, an ex-Subject Leader for Art & Design and was a member of the NSEAD Curriculum Writing Group that wrote the art curriculum competencies, more formally called the: 'Framework for Progression, Planning for Learning, Assessment, Recording and Reporting 2014.'

#0027 - 191018 - C0 - 246/189/6 - PB - 9781909671195